Harry Potter ™

FILM VAULT

VOLUME 5

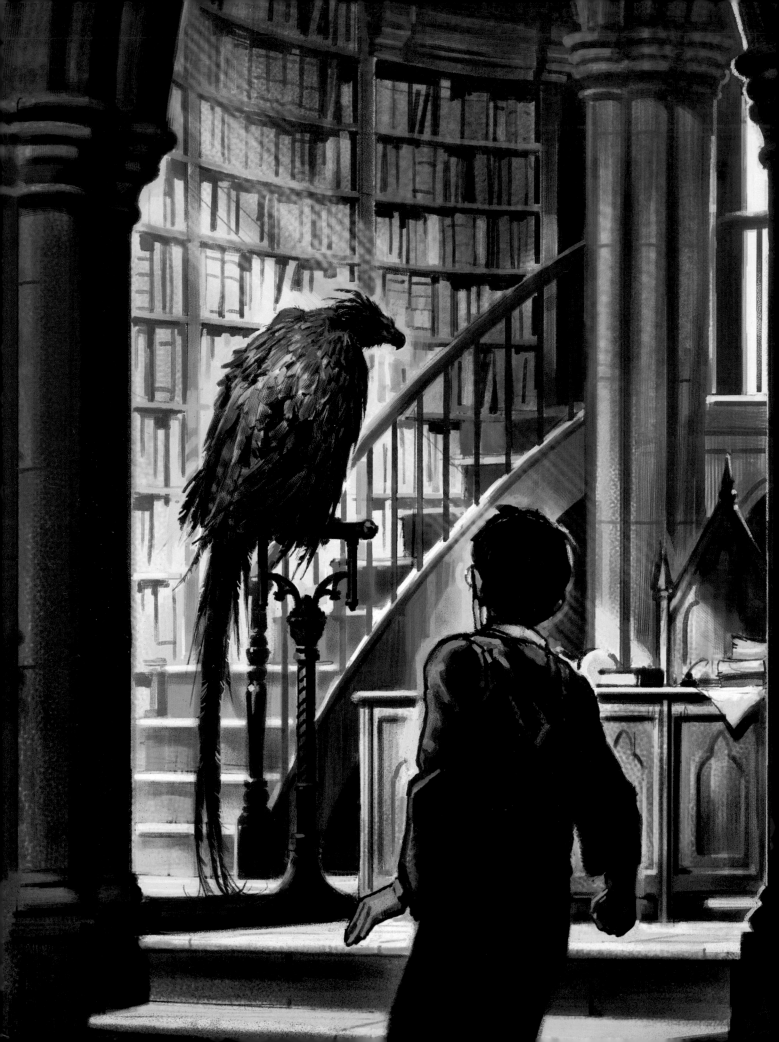

Harry Potter™

FILM VAULT

Volume 5

Creature Companions, Plants, and Shapeshifters

By Jody Revenson

WIZARDING WORLD

INSIGHT ◉ EDITIONS

San Rafael • Los Angeles • London

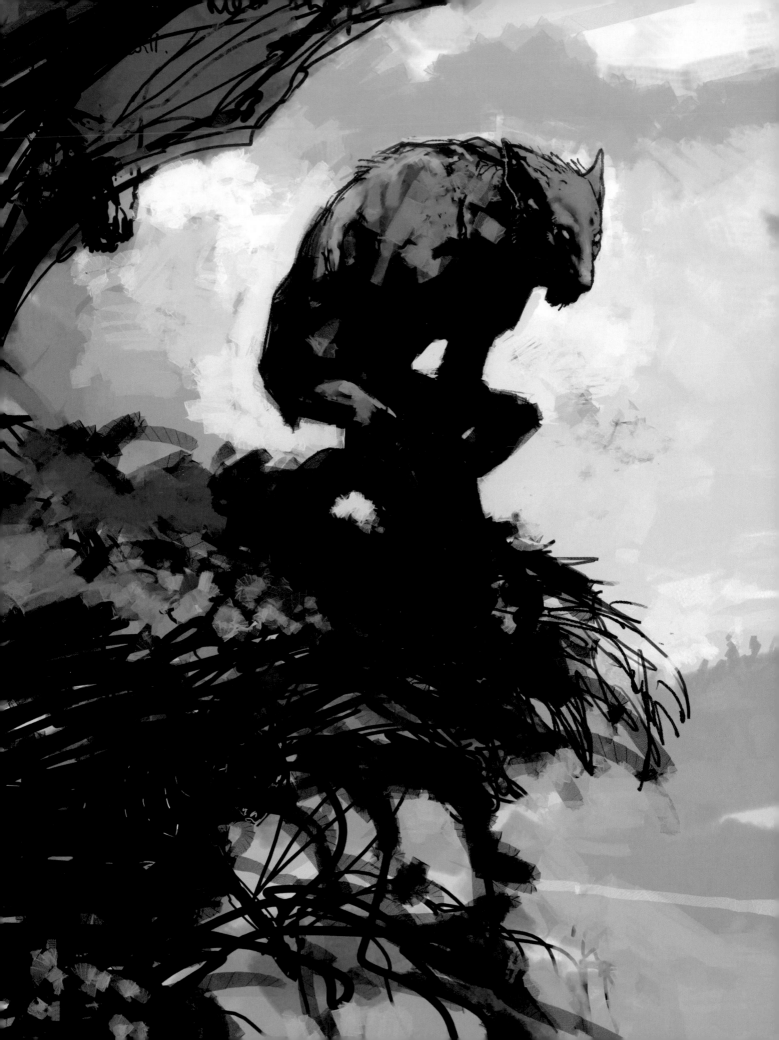

INTRODUCTION

When Harry Potter receives his invitation to attend Hogwarts School of Witchcraft and Wizardry, he also receives a list of supplies needed for his first year. In addition to utilitarian items, including a wand, a cauldron (pewter, standard size 2), and one pair of protective gloves (dragon hide or similar), students may also bring with them an owl, a cat, or a toad. Cats, toads, and other small animals have a historical relevance to the world of magic, but for Harry Potter's story, these animals provide companionship, inspiration, and sometimes the answer to a mystery Harry must solve or an obstacle he must overcome. Every animal, says producer David Heyman, "is important to the story."

Highly talented real-life animals, some who had already appeared in movies and many who were rescues, were trained in behaviors that served the story. The real rat, Dex, who often played Ron's rat, Scabbers, learned to run from point A to point B and stop on a dime during a scene in *Harry Potter and the Prisoner of Azkaban* where the rat escapes from Ron's grasp and flees away across a hill. Dex was also able to learn a new behavior quickly, especially when the direction of Scabbers's run changed to go from point A to a new point C during filming.

Every measure of care was taken for these animal actors. Warming pads were hidden on cold stone floors for the cats' paws. The floor of the Forbidden Forest was covered in a soft moss when Rubeus Hagrid brought his dog, Fang, there, in order to provide a stable footing and to protect the dog's footpads. Animatronic versions were created for any stunts that might frighten the animals.

In addition to the "everyday" animals seen on-screen, there are magical creatures that are deeply rooted in mythology, but rethought and reenvisioned in new ways. Many of these are shapeshifters, such as werewolves and Animagi. When special makeup designer and head of the creature shop Nick Dudman heard there would be a werewolf in the third film, he wasn't sure about the challenge, as movie werewolves are so iconic. However, author J. K. Rowling had created a character whose transformation into a werewolf did not increase danger, but sympathy. "And the thing that was interesting about Remus Lupin's werewolf design was

it didn't look like anything that had been done before," says Dudman. Fenrir Greyback was another werewolf whose look was also non-iconic: It came from his desire to be both man and wolf at the same time. For his creature creations, "My personal preference is always to provide something that the director can treat as just another performer," says Dudman, "and not be limited by the constraints of how it is actually constructed."

In addition to magical creatures, there are magical plants and trees in the Wizarding World—cactus-like plants in pots that splash about a foul-smelling substance when touched or a tree that "whomps" anything that gets near its branches. But all these flora are there for a reason, including being able to save a life, such as Mandrakes do when they provide the ingredients for a potion that saves several students, a cat, and a ghost who have been Petrified in *Harry Potter and the Chamber of Secrets*.

The Wizarding World contains many fascinating creatures who are as individualistic, and as important, as the human characters in the story. In *Harry Potter and the Sorcerer's Stone*, a toad emulates the burgeoning heroism of its owner who is trying to prevent his friends from going on a dangerous mission. In *Harry Potter and the Prisoner of Azkaban*, the expected antagonism between a cat and a rat turns out to be far from the cliché, when the rat turns out to be an Animagus—a person who can turn themselves into a specific animal at will—who has a nasty history and an even nastier agenda. Even magical plants like the screeching adolescent Mandrakes become characters you can root for.

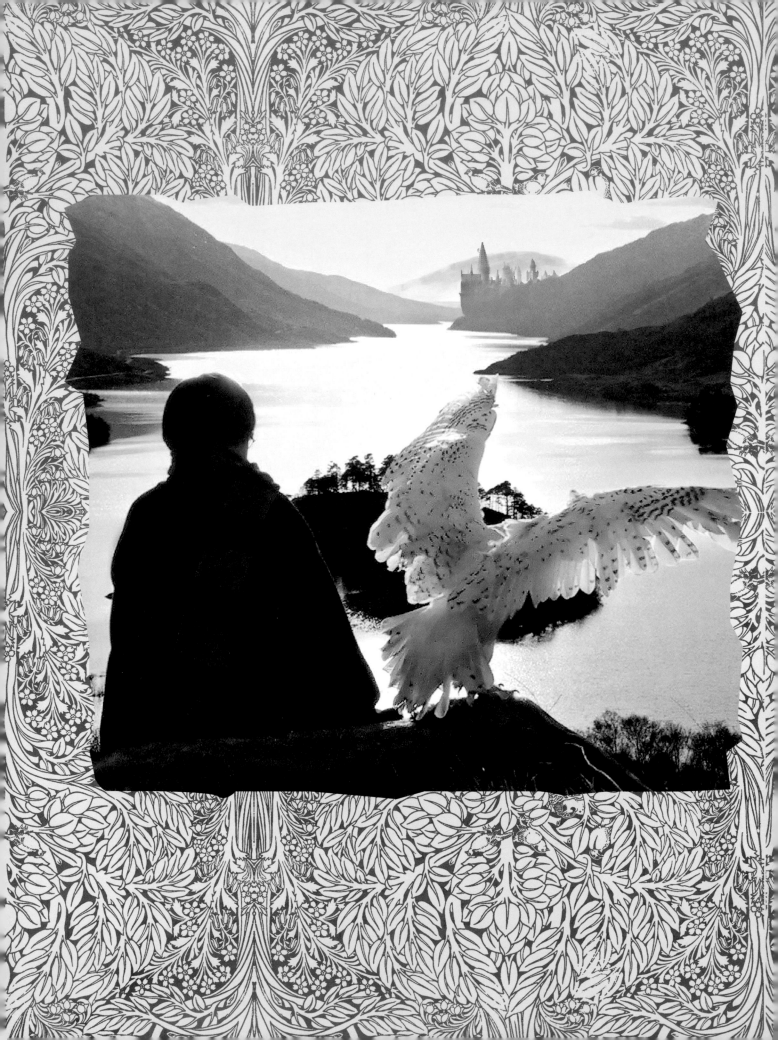

CHAPTER ONE

CREATURE COMPANIONS

Accompanying the acceptance letter to Hogwarts School of Witchcraft and Wizardry that Harry Potter receives in the first film is a list of supplies needed by first-year students. Along with cauldrons and wands, they are allowed to bring, if they desire, an owl, a cat, or a toad. For many characters in the films, these companions become trusted friends.

Hedwig

Hedwig is a snowy owl given to Harry Potter by Hagrid for his eleventh birthday, in *Harry Potter and the Sorcerer's Stone*. Hedwig often delivers messages for Harry and is able to find the addressee even if she is not given a specific address, as is the case with Sirius Black in *Harry Potter and the Goblet of Fire*.

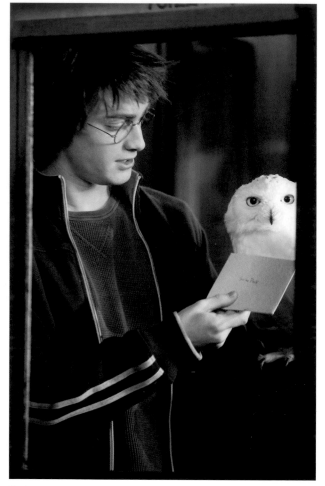

Fig 1.

The role of Hedwig was played by several male snowy owls throughout the Harry Potter series, most notably by a snowy owl named Gizmo. The other owls included Kasper, Ook, Swoops, Oh Oh, Elmo, and Bandit. Female owls are larger and have darker markings than male owls, so the lighter male was easier for Daniel Radcliffe (Harry Potter) to work with. Radcliffe's arm was protected by a thick leather arm guard, similar to the type used in falconry, when Gizmo perched upon it. Gizmo had stand-ins that would take his place when the lighting for scenes was being worked out, as well as for some flying sequences.

One of Hedwig's biggest scenes takes place in *Harry Potter and the Sorcerer's Stone*, when Professor McGonagall presents new Gryffindor Seeker Harry with a Nimbus 2000. It took roughly six months to train Gizmo with the needed behavior. For this, Gizmo carried a broom made from plastic tubing that was lighter in weight than most owls' prey. The broom was held by a temporary attachment to his talons, but like the other Owl Post deliveries, it was tied to a harness mechanism that the trainer released in the right spot for Harry (Daniel Radcliffe) to catch.

Page 6. Harry Potter at Hogwarts with his companion, Hedwig, at his side in a scene envisioned for *Harry Potter and the Sorcerer's Stone* by Dermot Power; Fig 1. Harry (Daniel Radcliffe) and Hedwig (Gizmo) in a scene from *Harry Potter and the Goblet of Fire*; Fig 2. Harry (Daniel Radcliffe) and Hedwig (Gizmo) in *Harry Potter and the Sorcerer's Stone*. Beneath Radcliffe's robe's sleeve is a protective leather sheath; Fig 3. A publicity photo of Hedwig (Gizmo) flying; Fig 4. Hedwig (Gizmo) sits patiently in the Gryffindor common room in *Harry Potter and the Half-Blood Prince*; Fig 5. Hedwig (Gizmo) and trainer.

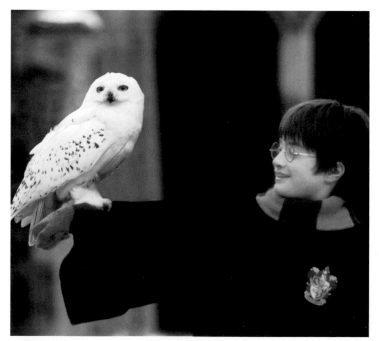

Fig 2.

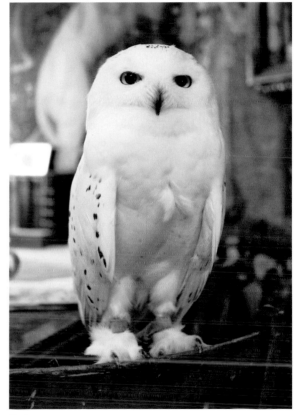

Fig 3.

FAST FACTS

HEDWIG

✶

I. FIRST FILM APPEARANCE: *Harry Potter and the Sorcerer's Stone*

II. ADDITIONAL FILM APPEARANCES: *Harry Potter and the Chamber of Secrets, Harry Potter and the Prisoner of Azkaban, Harry Potter and the Goblet of Fire, Harry Potter and the Order of the Phoenix, Harry Potter and the Half-Blood Prince, Harry Potter and the Deathly Hallows – Part 1*

III. LOCATION: Number 4, Privet Drive, Hogwarts, The Owlery, Diagon Alley, The Burrow, The Leaky Cauldron

IV. OWNER: Harry Potter

V. ANIMAL ACTORS: Gizmo, plus Kasper, Ook, Swoops, Oh Oh, Elmo, and Bandit

VI. DESCRIPTION FROM *HARRY POTTER AND THE SORCERER'S STONE* **BOOK, CHAPTER FIVE:**
"Harry now carried a large cage that held a beautiful snowy owl . . ."

Fig 4.

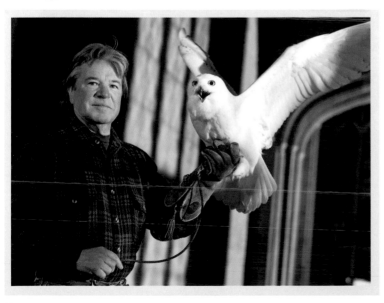

Fig 5.

> " *Right smart bird you've got there, Mr. Potter. It arrived here just five minutes before yourself.*"
> —TOM, INNKEEPER AT
> THE LEAKY CAULDRON
> *Harry Potter and the Prisoner of Azkaban* film

Errol

Errol belongs to the Weasley family and is not the most graceful of owls, as observed by Harry Potter on his first visit to The Burrow, in *Harry Potter and the Chamber of Secrets*, when Errol slams into the window. Errol also manages to upset a bowl of potato chips when he delivers a Howler to Ron Weasley in the Great Hall of Hogwarts. Errol is a bit old and a bit slow, so the filmmakers had fun with this character as a comic contrast to Hedwig.

Fig 1.

" *Sorry I'm late. The owl that delivered my release papers got all lost and confused. Some ruddy bird called Errol.*"

—RUBEUS HAGRID

Harry Potter and the Chamber of Secrets film

Fig 2.

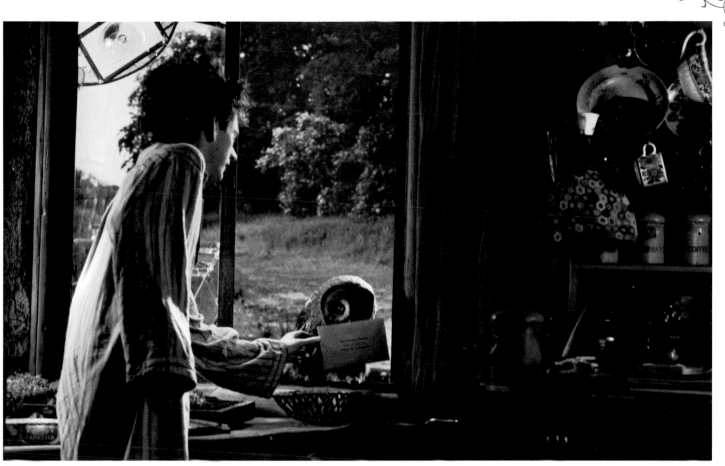

Fig 3.

ERROL

✳

I. FILM APPEARANCE: *Harry Potter and the Chamber of Secrets*

II. LOCATION: The Burrow, Hogwarts

III. OWNERS: The Weasley family

IV. ANIMAL ACTOR: Zeus

V. DESCRIPTION FROM *HARRY POTTER AND THE CHAMBER OF SECRETS* BOOK, CHAPTER THREE:

"Our owl. He's ancient. It wouldn't be the first time he'd collapsed on a delivery."—Ron Weasley

Errol was played by Zeus, a great gray owl, which is considered the largest species of owl worldwide. Zeus received training for all of his character's actions in *Harry Potter and the Chamber of Secrets*, except one. He could fly with an envelope in his mouth, and was taught to lie down and then get back up. Owls have hollow bones; consequently they cannot be trained to crash into anything solid. So Zeus was filmed flying gracefully through the kitchen window of The Burrow, and then filmed "getting up" from the counter. This footage was combined with that of a digital Errol colliding with the window.

Fig 1. Animal trainer Gary Gero and Zeus, who played the Weasley's clumsy owl, Errol, in *Harry Potter and the Chamber of Secrets*; Fig 2. The animatronic version of Errol in the creature shop; Fig 3. Percy Weasley helps the aged, ungainly owl into The Burrow in a scene from *Chamber of Secrets*.

Pigwidgeon

In the book *Harry Potter and the Goblet of Fire*, Pigwidgeon, an extremely small owl, is given to Ron by his family to replace Scabbers. However, while Pigwidgeon appeared in a promotional photograph for the film of the same book, and was filmed at Platform 9¾ for a scene that did not appear in the final film cut of *Harry Potter and the Order of the Phoenix*, his on-screen debut came in *Harry Potter and the Half-Blood Prince*, where he can be seen perched on a chair in the Gryffindor common room. Pigwidgeon was played by Mars, a scops owl, which is one of the smallest species of owls.

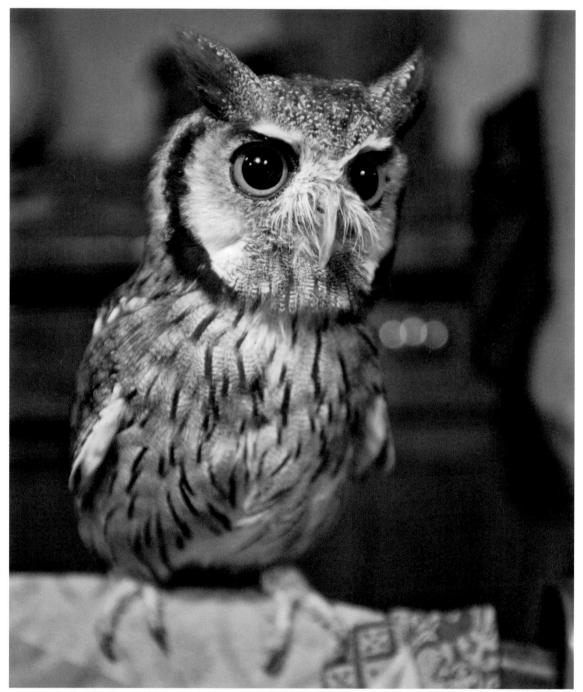

Fig 1. (above) Mars (Pigwidgeon) in a publicity shot; Fig 2. Rupert Grint (Ron Weasley) holds Mars (Pigwidgeon) in a publicity shot for *Harry Potter and the Goblet of Fire*, though Mars did not actually appear in the film; Fig 3. Pigwidgeon (Mars) near Ron's bed in a rare outtake from *Goblet of Fire*. Mars's film debut came in *Harry Potter and the Half-Blood Prince*.

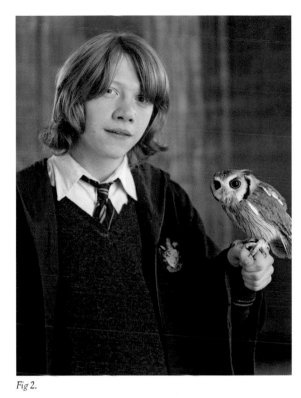

Fig 2.

FAST FACTS

PIGWIDGEON

I. FILM APPEARANCE: *Harry Potter and the Half-Blood Prince*

II. LOCATION: Gryffindor common room, Hogwarts

III. OWNER: Ron Weasley

IV. ANIMAL ACTOR: Mars

V. DESCRIPTION FROM *HARRY POTTER AND THE GOBLET OF FIRE* BOOK, CHAPTER THREE:
"'OUCH!' said Harry, as what appeared to be a small, gray, feathery tennis ball collided with the side of his head."

Fig 3.

Scabbers

Scabbers is Ron Weasley's pet rat, handed down from his brother Percy. Ron brings Scabbers to Hogwarts in his first year, in *Harry Potter and the Sorcerer's Stone*. The rat is temporarily turned into a goblet during Transfiguration class in *Harry Potter and the Chamber of Secrets* by Ron's broken wand. It is in *Harry Potter and the Prisoner of Azkaban* that Scabbers is discovered to be the Animagus form of Peter Pettigrew, who escapes the Hogwarts grounds, losing Ron his rat.

The various incarnations of Scabbers over the course of the Harry Potter series were played by twelve real and several animatronic rats. The animal actor who primarily played the part was named Dex, who, with the other rats, was trained to run to and stay on a mark. Rats are very intelligent creatures and easy to train. In *Harry Potter and the Sorcerer's Stone*, Scabbers's big set piece is having his head caught in a candy box and being forced out when Ron tries a spell on him. An animatronic rat was used for the majority of the scene, but Dex was used at the last moment of the spell, "backing out" of the candy box to end up sitting on Ron's (Rupert Grint) lap. A trainer placed a candy box that was attached to a wire over Dex's head and then gently pulled it off on cue.

It took roughly four months to train Dex and Crackerjack, the cat that played Crookshanks, to run down the hallway in their opening scene of *Harry Potter and the Prisoner of Azkaban*. The animals had already become used to each other, so training them was simply a matter of teaching them to run in the same direction. Training methods included having the animals run next to each other in parallel runways created by soft netting, in the direction of a food reward. The only challenge for this scene was that Crackerjack would often overtake Dex, who was so used to the cat that he wasn't running as fast as any rat normally should have.

> "*Sunshine, daisies, butter mellow, turn this stupid fat rat yellow.*"
> —RON WEASLEY
> *Harry Potter and the Sorcerer's Stone* film

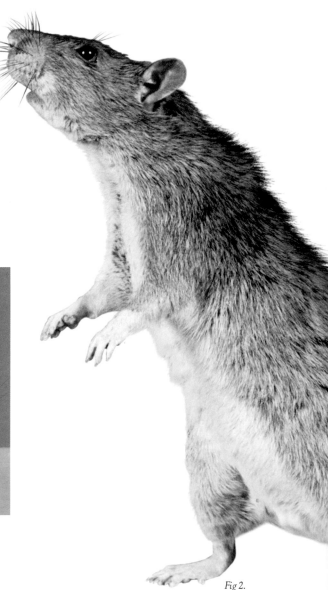

Fig 1.

Fig 2.

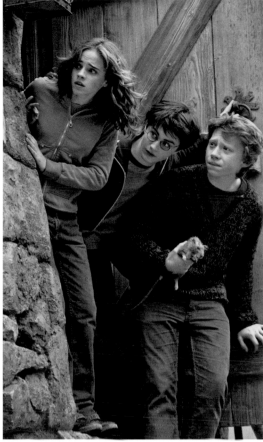

Fig 3.

This is Scabbers, by the way. Pathetic, isn't he?"

—RON WEASLEY

Harry Potter and the Sorcerer's Stone film

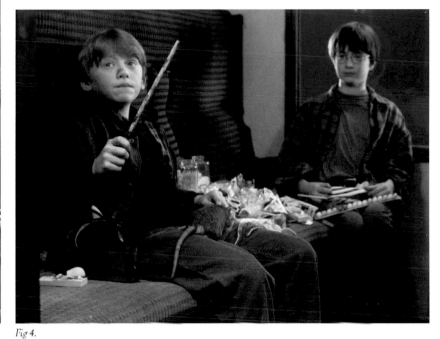

Fig 4.

Fig 5.

FAST FACTS

SCABBERS

✳

I. FIRST FILM APPEARANCE: *Harry Potter and the Sorcerer's Stone*

II. ADDITIONAL FILM APPEARANCES: *Harry Potter and the Chamber of Secrets, Harry Potter and the Prisoner of Azkaban*

III. OWNER: Ron Weasley

IV. ANIMAL ACTOR: Dex

V. DESCRIPTION FROM *HARRY POTTER AND THE SORCERER'S STONE* BOOK, CHAPTER SIX:

"Ron reached into his jacket and pulled out a fat gray rat, which was asleep."

Figs 1. & 2. Dex, the rat who played the dual role of Scabbers/Wormtail; Fig 3. Hermione Granger (Emma Watson) and Harry Potter (Daniel Radcliffe) with Ron Weasley (Rupert Grint) holding Scabbers (Dex) in a scene from *Harry Potter and the Prisoner of Azkaban*; Fig 4. Scabbers (Dex) goes after the candy on Ron's lap as Harry looks on in a scene from *Harry Potter and the Sorcerer's Stone*; Fig 5. A publicity shot of Rupert Grint (Ron Weasley) with Dex (Scabbers) for *Sorcerer's Stone*.

Crookshanks

Hermione Granger acquires Crookshanks, a large ginger cat, in her third year at Hogwarts, in the film *Harry Potter and the Prisoner of Azkaban*. Our first view of Crookshanks is as a streak of orange careening after Scabbers, Ron's rat, in the hallways of The Leaky Cauldron. Crookshanks exhibits his playful nature in *Harry Potter and the Order of the Phoenix* when Fred and George dangle an Extendable Ear over the staircase at number 12, Grimmauld Place.

Crookshanks was played by four different red Persian cats over the course of the films. Oliver, who was seen in *Prisoner of Azkaban*, was a rescue cat. Bo Bo was the youngest cat and very energetic, so he did well for any action scenes. He was one of the cats trained to chase Scabbers in the third film, and also appeared in *Order of the Phoenix*. Prince preferred to be carried and held above anything else. He was only seen in *Order of the Phoenix*.

Crookshanks was most frequently played by Crackerjack, who made his screen debut in *Prisoner of Azkaban*. Crookshanks's matted coat was created with what could be called "fur extensions." Each time Crackerjack was groomed, his trainers would keep the brushed-out undercoat fur and ball it into little blobs that would be clipped onto the cat's fur. A clear, sting-free jelly-like substance gave him runny eyes, and an animal-safe brown "eye shadow" was streaked around his eyes and mouth to create a cross look on the well-dispositioned cat.

Crackerjack, who could stop on a mark on cue, learned a retrieving skill for the Extendable Ear scene in *Harry Potter and the Order of the Phoenix*. Crookshanks bats at the Ear, wrestles with it, and then manages to yank it down and carry it away to the dismay of the young Weasleys and their friends. The trainers spent the better part of three months teaching the team of cats to play with and then grab the Ear, take it away, and drop it in a bowl off camera, where they would be rewarded with a kitty treat.

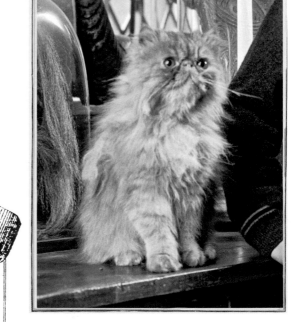

Fig 1. (above) Crackerjack (Crookshanks) in a publicity photo for *Harry Potter and the Prisoner of Azkaban*.

FAST FACTS

CROOKSHANKS

✳

I. FIRST FILM APPEARANCE: *Harry Potter and the Prisoner of Azkaban*

II. ADDITIONAL FILM APPEARANCES:
Harry Potter and the Goblet of Fire
Harry Potter and the Order of the Phoenix
Harry Potter and the Half-Blood Prince

III. OWNER: Hermione Granger

IV. ANIMAL ACTORS: Crackerjack, Prince, Pumpkin, Oliver, and Bo Bo

V. DESCRIPTION FROM *HARRY POTTER AND THE PRISONER OF AZKABAN* BOOK, CHAPTER FOUR:
"The cat's ginger fur was thick and fluffy, but it was definitely a bit bowlegged and its face looked grumpy and oddly squashed, as though it had run headlong into a brick wall."

> "*A cat! Is that what they told you? Looks more like a pig with hair if you ask me.*"
>
> —RON WEASLEY
> *Harry Potter and the Prisoner of Azkaban* film

Mrs. Norris

Mrs. Norris is the companion of Hogwarts caretaker Argus Filch. She seems to have an uncanny sense for happening upon misbehaving students that aids in her patrol of the corridors, and an almost supernatural connection to Filch, who benefits from her vigilance. Mrs. Norris's closeness to Filch is apparent from her first appearance in *Harry Potter and the Sorcerer's Stone*. In *Harry Potter and the Goblet of Fire*, Filch and Mrs. Norris enjoy a dance at the Yule Ball.

Through the entire course of the eight Harry Potter films, Mrs. Norris was played by three tabby Maine Coon cats, named Maximus (Max), Alanis (the only female cat), and Cornelius, and occasionally an animatronic cat. Each cat had a specialty according to David Bradley, the actor who played Argus Filch. Max was good at running to or alongside him, and could even jump on his back and sit on his shoulder on cue, as seen in *Harry Potter and the Order of the Phoenix*. Max got the most screen time of these cats and was seen in every film in which David Bradley appeared as Filch—the only film they weren't in was *Harry Potter and the Deathly Hallows – Part 1*. Bradley remembers that Max could run at him, climb up his legs, and end up on his shoulder, though sometimes he ended up facing the wrong way to the camera (and was asked to do it again). Oftentimes he would place his tail over Bradley's face like a mustache.

Alanis was so good at resting in Bradley's arms during shooting that she fell asleep several times. A bona fide cat lover, Bradley needed only to rub her gently on her head and she would

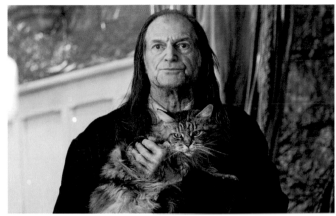

Fig 3.

wake up and play her part. As the stone floors in Hogwarts were often chilly, all the cats, including those that played Professor McGonagall's Animagus and Hermione's cat, Crookshanks, were provided heated floors to keep their bodies, and especially their paws, warm. In order to perform their behaviors, the cats were trained to respond to a clicking sound by attaching a clicker to their food bowl. A bar with a clicker was attached to their food bowl that clicked when it was pressed, afterward their kitty treat reward would fall into the bowl. The animal trainers had a remote-controlled clicker placed in one of David Bradley's boots, so Mrs. Norris would follow Filch around. Of course, the cats would be rewarded with a treat after the scene!

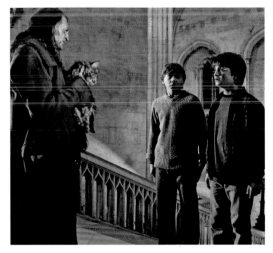

Fig 2. (above) Argus Filch (David Bradley) and the ubiquitous Mrs. Norris confront Ron Weasley (Rupert Grint) and Harry Potter (Daniel Radcliffe) in *Harry Potter and the Chamber of Secrets*; Fig 3. Filch (David Bradley) takes Mrs. Norris to the Yule Ball in *Harry Potter and the Goblet of Fire*.

FAST FACTS

MRS. NORRIS

✳

I. FIRST FILM APPEARANCE: *Harry Potter and the Sorcerer's Stone*

II. ADDITIONAL FILM APPEARANCES:
Harry Potter and the Chamber of Secrets, Harry Potter and the Prisoner of Azkaban, Harry Potter and the Goblet of Fire, Harry Potter and the Order of the Phoenix, Harry Potter and the Half-Blood Prince, Harry Potter and the Deathly Hallows – Part 2

III. LOCATION: Hogwarts castle • IV. OWNER: Argus Filch

V. ANIMAL ACTORS: Maximus, Alanis, and Cornelius

VI. DESCRIPTION FROM *HARRY POTTER AND THE SORCERER'S STONE* BOOK, CHAPTER EIGHT:
"Filch owned a cat called Mrs. Norris, a scrawny, dust-colored creature with bulging, lamplike eyes just like Filch's."

Fang

It is no surprise in the Harry Potter films that Fang, the companion to a half-giant such as Rubeus Hagrid, would be a dog equally gigantic when compared to most other breeds. Though Fang is large, he isn't necessarily as brave as expected, as discovered in *Harry Potter and the Sorcerer's Stone*. To accommodate these facets of his character, Fang was played by a series of Neapolitan Mastiffs, a dog known for its massive head and body, but one that has a very peaceful nature.

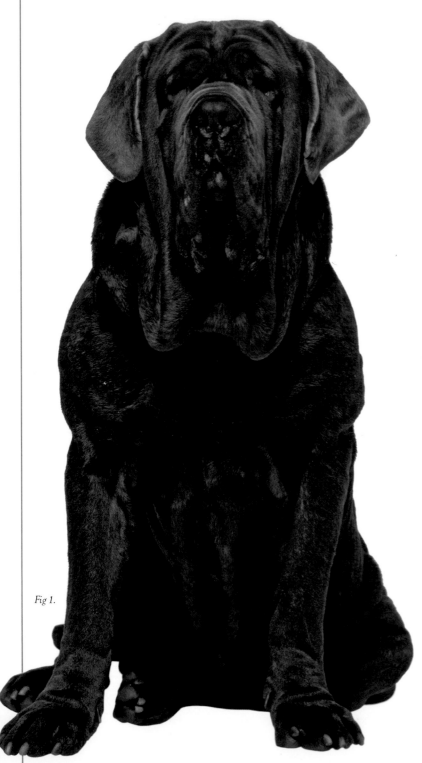

Fig 1.

In the Harry Potter novels by J. K. Rowling, Fang is a boarhound, also known as a Great Dane, but the animal department decided to use Neapolitan Mastiffs, which are one of the world's oldest dog breeds. (And also one of the drooliest!) From *Harry Potter and the Sorcerer's Stone* through *Harry Potter and the Prisoner of Azkaban*, Fang was played by a Mastiff named Hugo. Monkey took the role in *Harry Potter and the Goblet of Fire*, *Harry Potter and the Order of the Phoenix*, and *Harry Potter and the Half-Blood Prince*. Other dogs that worked in the role were Bella, who was the smallest dog of them all, and Gunner and Luigi, who were both seen in *Prisoner of Azkaban*. Back-up dogs, unfortunately not seen on-screen, included Uno and Bully, who was a rescue success story: Bully was adopted by one of the animal trainers after the film finished shooting.

When Harry and Ron make their escape from the Forbidden Forest in the Ford Anglia car, two Fangs were used. Bella, the dog who was most comfortable working in cars, was one, and an animatronic version of Fang was used

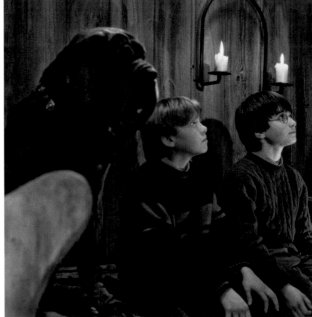

Fig 2.

" *Just so's yeh know, he's a bloody coward.*"
— RUBEUS HAGRID
Harry Potter and the Sorcerer's Stone film

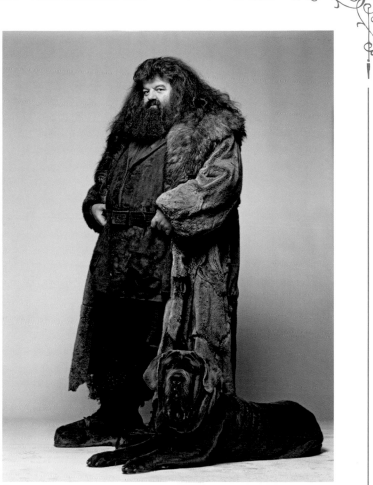

Fig 1. A publicity shot of Hugo, one of the many Neapolitan Mastiffs who played Fang for *Harry Potter and the Sorcerer's Stone*; Fig 2. Harry, Ron, and Fang in a scene for *Harry Potter and the Sorcerer's Stone*; Fig 3. Publicity shot of Hagrid and Fang; Fig 4. Harry and Draco are accompanied by Fang as they serve detention in the Forbidden Forest in *Harry Potter and the Sorcerer's Stone*.

Fig 3.

Fig 4.

when the car race out of the forest. The animatronic Fang was radio-controlled to move and even to drool.

For *Order of the Phoenix*, Monkey was required to catch a piece of steak and chew on it. The trainers limited the number of takes for this scene, although they kidded that this might be the only time an actor would ask to do more takes. All the dogs were cued by trainers who were off camera to Sit, Stay, Speak, and Come, but no trainer yet has been able to teach a Neapolitan Mastiff the Don't Drool behavior.

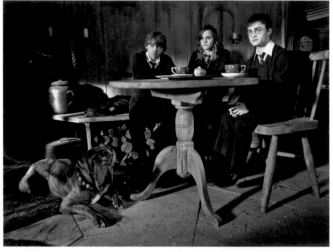

Fig 1.

Fig 2.

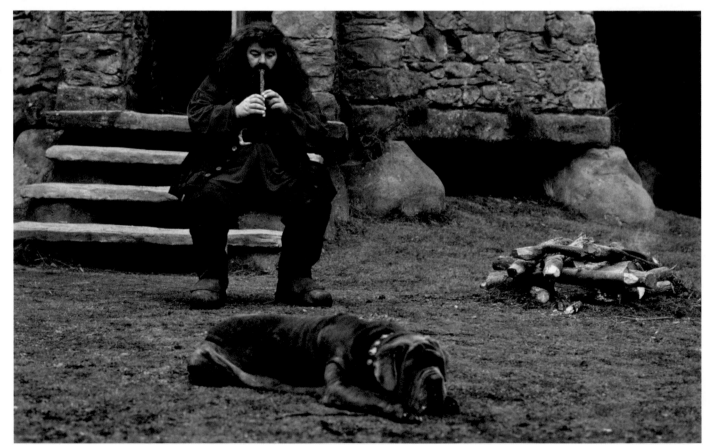

Fig 3.

FAST FACTS

FANG

✳

I. FIRST FILM APPEARANCE: *Harry Potter and the Sorcerer's Stone*

II. ADDITIONAL FILM APPEARANCES: *Harry Potter and the Chamber of Secrets, Harry Potter and the Prisoner of Azkaban, Harry Potter and the Order of the Phoenix, Harry Potter and the Half-Blood Prince*

III. LOCATION: Hagrid's hut, Forbidden Forest

IV. OWNER: Hagrid

V. ANIMAL ACTORS: Hugo, Monkey, Bella, Gunner, Luigi, Uno, and Bully

VI. DESCRIPTION FROM *HARRY POTTER AND THE SORCERER'S STONE* BOOK, CHAPTER EIGHT:
"[Hagrid] let them in, struggling to keep a hold on the collar of an enormous black boarhound."

Fig 1. Harry, Ron, Hermione, and Fang on the Hagrid's hut set, *Harry Potter and the Order of the Phoenix*; Fig 2. Fang poses for a publicity shot, along with fellow animal actors; Fig 3. Hagrid plays the flute as Fang relaxes in *Harry Potter and the Sorcerer's Stone*; Fig 4. A publicity shot of Fang.

Fig 4.

Trevor

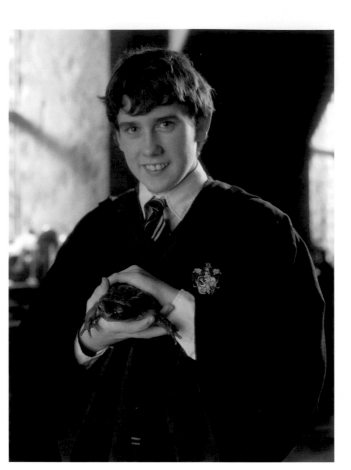

Neville Longbottom brings a toad with him to his first year at Hogwarts and promptly loses it in *Harry Potter and the Sorcerer's Stone*.

Four toads performed the role of Neville's companion, Trevor, through the course of the Harry Potter series. The toads were kept in a heated, moss-based terrarium. When Trevor was needed for a scene, a trainer would place the toad in Matthew Lewis's (Neville Longbottom) hands, on the floor, or on the arm of a chair. As soon as the scene was finished, the trainer would return the toad to the terrarium.

> "*Has anyone seen a toad?*
> *A boy named Neville's lost one.*"
> —HERMIONE GRANGER
> *Harry Potter and the Sorcerer's Stone* film

Fig 1. (above) Matthew Lewis (Neville Longbottom) and one of the toads who played Trevor in a publicity shot for *Harry Potter and the Prisoner of Azkaban*; Fig 2. Ginny Weasley's Pygmy Puff Arnold in unpuffed and puffed forms by Rob Bliss for *Harry Potter and the Half-Blood Prince*.

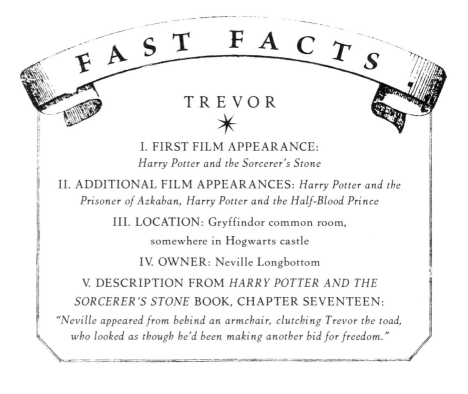

FAST FACTS

TREVOR

✳

I. FIRST FILM APPEARANCE:
Harry Potter and the Sorcerer's Stone

II. ADDITIONAL FILM APPEARANCES: *Harry Potter and the Prisoner of Azkaban, Harry Potter and the Half-Blood Prince*

III. LOCATION: Gryffindor common room, somewhere in Hogwarts castle

IV. OWNER: Neville Longbottom

V. DESCRIPTION FROM *HARRY POTTER AND THE SORCERER'S STONE* BOOK, CHAPTER SEVENTEEN:
"Neville appeared from behind an armchair, clutching Trevor the toad, who looked as though he'd been making another bid for freedom."

Arnold

inny Weasley finally got her own pet, a Pygmy Puff, in *Harry Potter and the Half-Blood Prince*. Purchased at her twin brothers' shop, Weasleys' Wizard Wheezes, the large-eyed creature happily sits on her shoulder as she shows the round pink puff-ball to Dean Thomas on the Hogwarts Express. Visual development art offered an opportunity to investigate what might be under all that fur, although inevitably the creature's digital designers chose to portray Arnold with the maximum hair allowed.

> *"He's lovely."*
>
> —LUNA LOVEGOOD
> *Harry Potter and the Half-Blood Prince* film

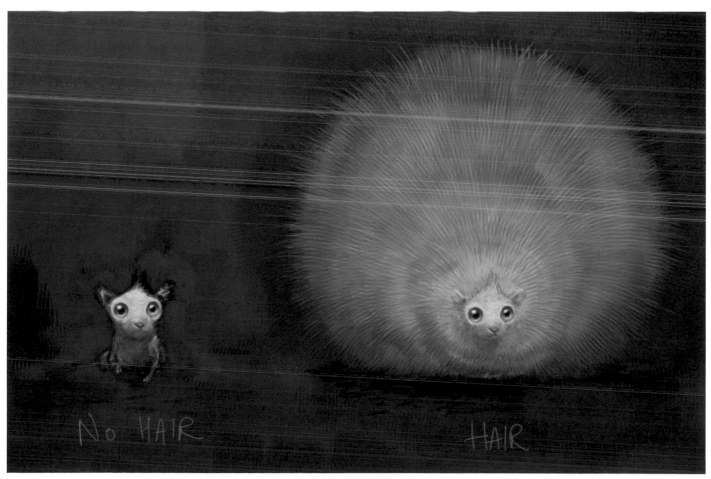

Fig 2.

Fawkes

Phoenixes are powerful magical birds that are immortal, as they regenerate in an infinite series of life cycles. A phoenix's powers include tears that have the ability to heal and the strength to carry extremely heavy loads. Harry Potter meets Fawkes in Dumbledore's office in *Harry Potter and the Chamber of Secrets*, just as the decrepit-looking bird bursts into flames. Dumbledore explains that this is natural for a phoenix, and they admire the new chick that rises through the pile of ash. Fawkes helps in the Chamber of Secrets by flying in with the Sorting Hat, which holds the Sword of Gryffindor. Fawkes also cures Harry of the Basilisk's wound with his tears, and flies Harry, Ron Weasley, and Gilderoy Lockhart out of the Chamber.

Fawkes appears in three stages of life: as an aged, frail bird that bursts into flames, as the chick born out of the ashes, and as the fully developed, powerful bird that assists Harry in defeating the Basilisk at the end of *Harry Potter and the Chamber of Secrets*. The visual development artist researched real birds in addition to artwork of the mythic phoenix for the design. Fawkes is a fusion of several powerful birds, most notably a sea eagle and a vulture. The exaggerated crest on his head has feathers sitting backward, which gave him a noble mien. His sharp beak and claws imposed an air of danger. In both his senior phase and as a newborn chick, Fawkes was given more of the vulture aesthetic, with a stretched-out neck and layered wrinkles. The visual designer was provided with a selection of tail feathers from pheasants and other game birds that he grouped together and manipulated to test feather composition and layering effects.

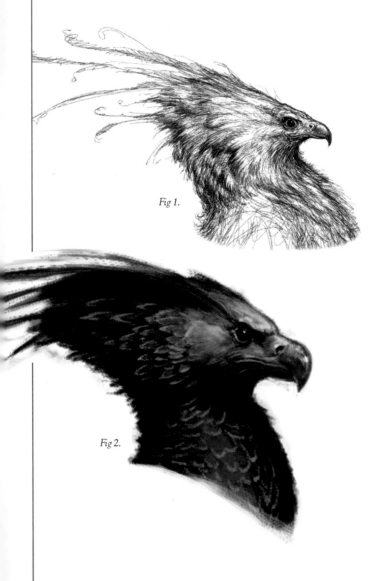

Fig 1.

Fig 2.

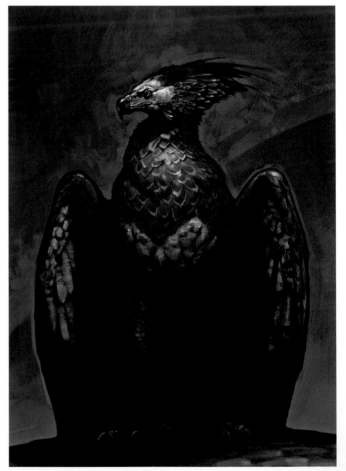

Fig 3.

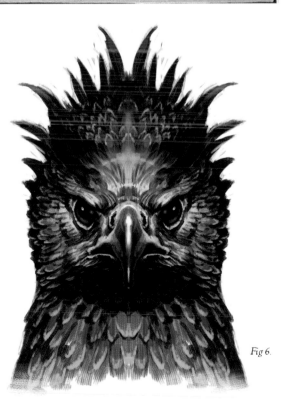

Fig 4.

Figs 1.—6. Studies of Fawkes the phoenix for *Harry Potter and the Chamber of Secrets* by Adam Brockbank, exploring the creature's colors and possible crest and wing styles.

Fig 5.

Fig 6.

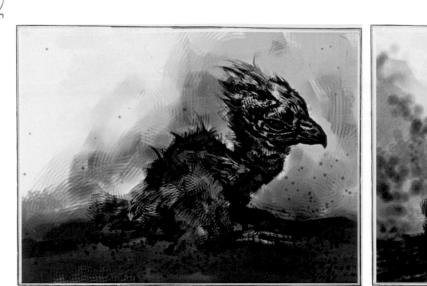

Fig 1.

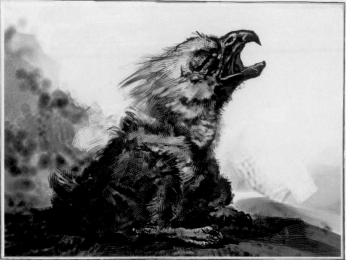

Fig 2.

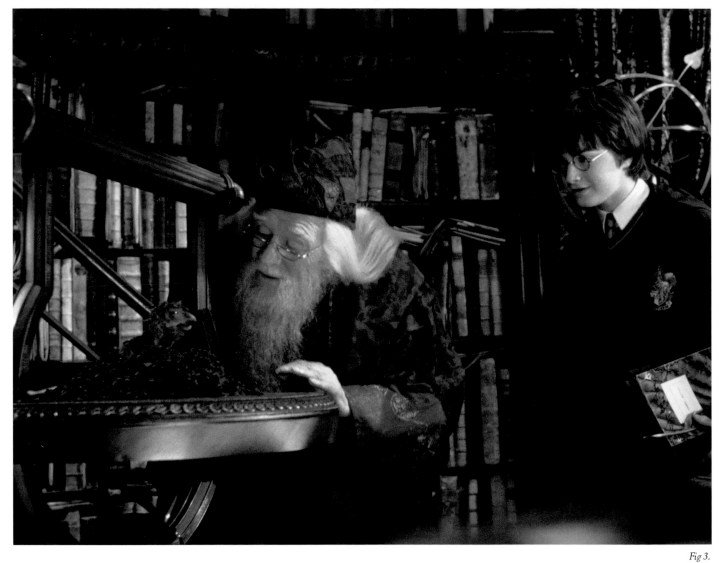

Fig 3.

Figs 1. & 2. Adam Brockbank portrays Fawkes rising from the ashes into his fledgling form for *Harry Potter and the Chamber of Secrets*; Fig 3. Albus Dumbledore (Richard Harris) explains the life cycle of the phoenix to Harry Potter (Daniel Radcliffe) in a scene from *Chamber of Secrets*; Adam Brockbank's art portrays Professor Dumbledore gently blowing the ashes from his beloved companion as Harry Potter looks on (Fig 4.) and Harry's first encounter with Fawkes, unfortunately on a Burning Day (Fig 5.).

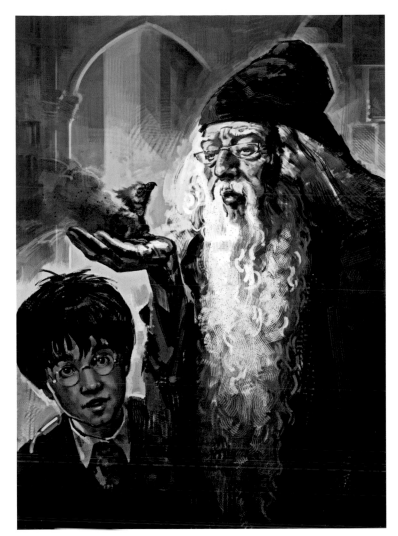

Fig 4.

Fawkes' coloring had to be fiery, with a palette of burnt oranges and dark reds. His underside is in shades of gold, as most birds have darker colorations on their tops than undersides. The phoenix's neck and throat are variegated oranges with a golden trim, likened to the coloring of a burnt-out match by concept artist Adam Brockbank. Baby Fawkes is a combination of a washed-out pinkish-red and the gray of the ashes from which he emerges. Each animatronic Fawkes was "feathered" by Val Jones, who did the same for Buckbeak in *Harry Potter and the Prisoner of Azkaban*. She used the feathers from game birds, some of which were specially dyed to create the bird's flame-like colors. The feathers were inserted into the model one at a time.

Fawkes was fully created in both animatronic and digital forms. The animatronic Fawkes, who had ten controllers generating his movements, could slide on his perch, raise his crest, blink, react to other characters, and stretch his wings out to their full length. This Fawkes was also able to cry the tears that needed to fall onto Harry Potter's (Daniel Radcliffe) arm to heal him from the Basilisk's venom. Richard Harris (Dumbledore) paid the creature designers the highest compliment when he was surprised to find out that Fawkes was anything other than a live, trained bird.

FAST FACTS

FAWKES

✳

I. FIRST FILM APPEARANCE: *Harry Potter and the Chamber of Secrets*

II. ADDITIONAL FILM APPEARANCES:
Harry Potter and the Goblet of Fire, Harry Potter and the Order of the Pheonix, Harry Potter and the Half-Blood Prince

III. LOCATION: Albus Dumbledore's office, Chamber of Secrets

IV. OWNER: Albus Dumbledore

V. DESCRIPTION FROM *HARRY POTTER AND THE CHAMBER OF SECRETS* BOOK, CHAPTER SEVENTEEN:
"A crimson bird the size of a swan had appeared . . . It had a glittering golden tail as long as a peacock's and gleaming golden talons . . ."

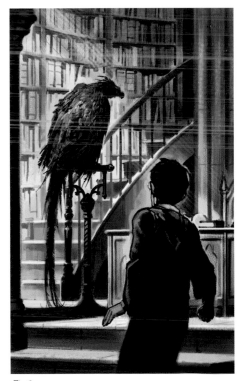

Fig 5.

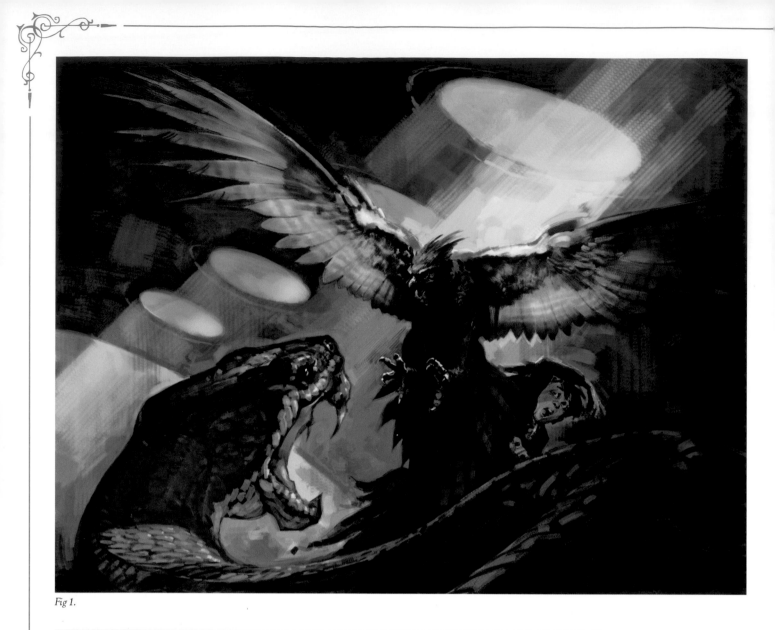

Fig 1.

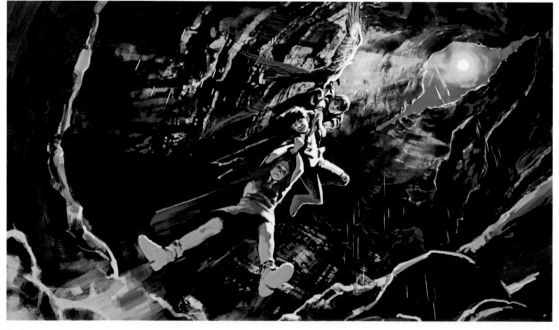

Fig 2.

Fawkes attacks the Basilisk in the Chamber of Secrets (Fig 1.), and rescues Harry, Ron and Ginny Weasley, and Professor Lockhart from the Chamber (Fig 2.), both by Adam Brockbank for *Harry Potter and the Chamber of Secrets*; Fig 3. The internal animatronic structure of Fawkes sits in the creature shop; Fig 4. Val Jones (left) and Josh Lee (right) work on the animatronic Fawkes in the creature shop; Fig 5. Fawkes's mechanical wing construct; Fig 6. The completed animatronic Fawkes set upon his perch.

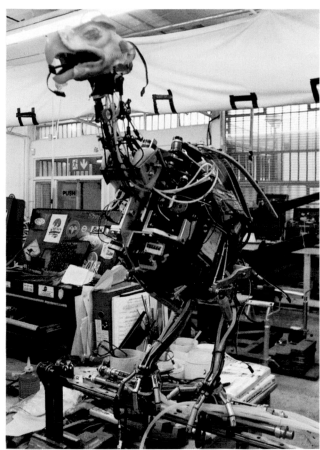

Fig 3.

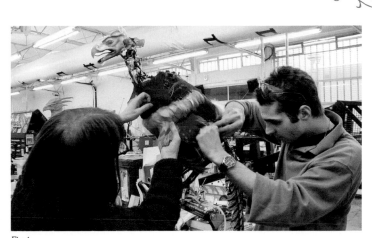

Fig 4.

Fig 5.

> "*Fawkes is a phoenix, Harry. They burst into flame when it is time for them to die, and then they are reborn from the ashes.*"
>
> —ALBUS DUMBLEDORE
> *Harry Potter and the Chamber of Secrets* film

The computer-generated version of Fawkes was not a cyber-scanned model, as were most creatures created for the Harry Potter series. The digital design team worked with the visual development artwork, and observed and filmed real birds as reference, specifically a turkey vulture and a blue macaw. The team realized that different softwares were needed to have the practical and CGI Fawkes analogous. Fawkes was modeled and animated in one software, then "feathered" in another. The feathers were laid on in a manner similar to roofing tiles, one atop the next, so they could curve around realistically. This version returned to the first software for lighting, and was then rendered for the screen in a third software. Fawkes's appearances in other Harry Potter movies, designed as a slimmed-down "midlife" Fawkes, were all CGI versions.

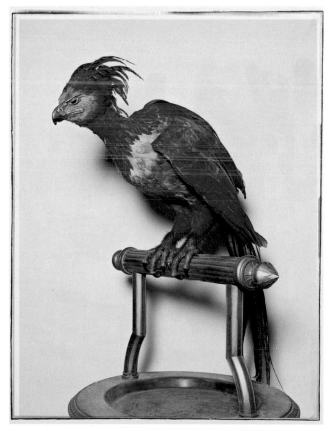

Fig 6.

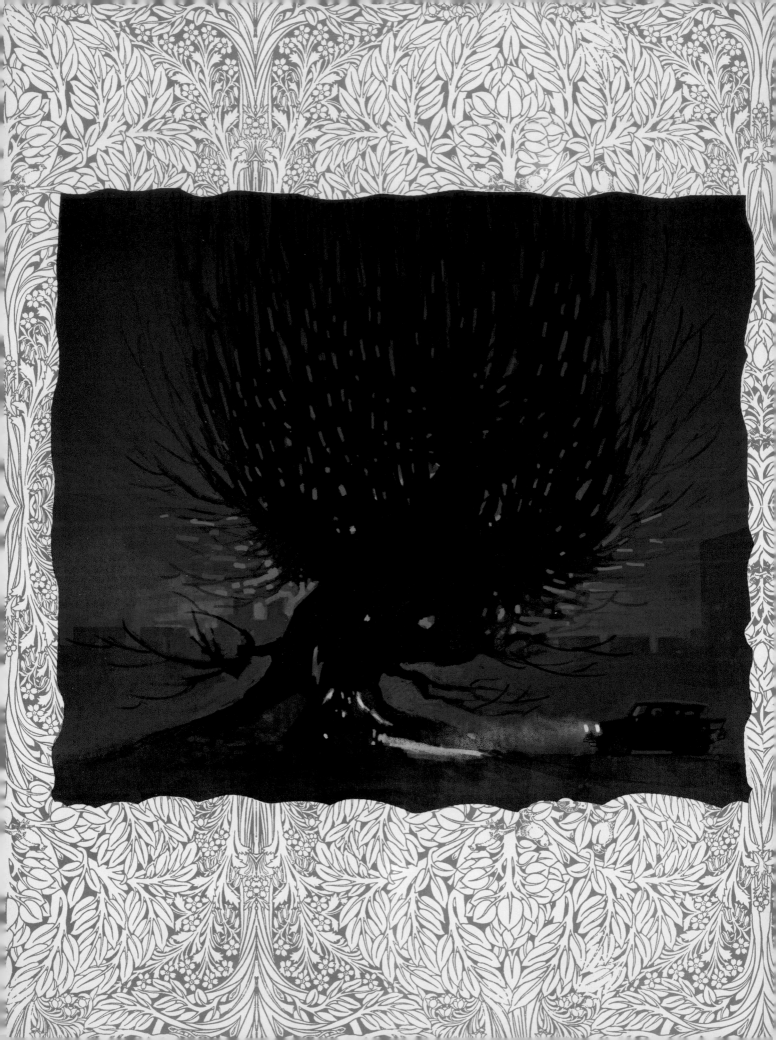

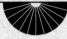

CHAPTER TWO

PLANTS

Creatures do not always walk, fly, or swim in the Harry
Potter films. Plants, whether rooted in the ground or in a
greenhouse, can have their own personalities and idiosyncrasies.
Some can be useful, like Mandrakes, or dangerous, like
the Whomping Willow. Some plants are prickly, like the
<u>Mimbulus mimbletonia</u>, and others are soft and enveloping.

Mandrake

The root of the Mandrake, or Mandragora, can be used to revive those who have been Petrified. In *Harry Potter and the Chamber of Secrets*, Herbology Professor Pomona Sprout assigns Mandrakes to her second-year students, and she instructs them to wear earmuffs, as Mandrake cries can kill a person.

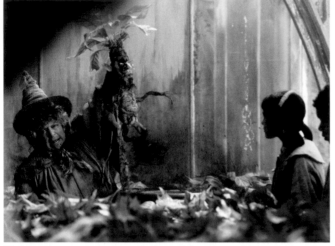

Fig 1.

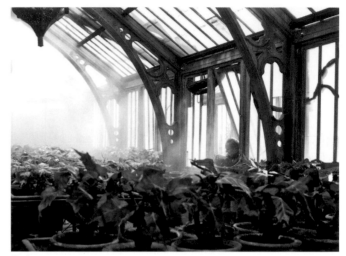

Fig 2.

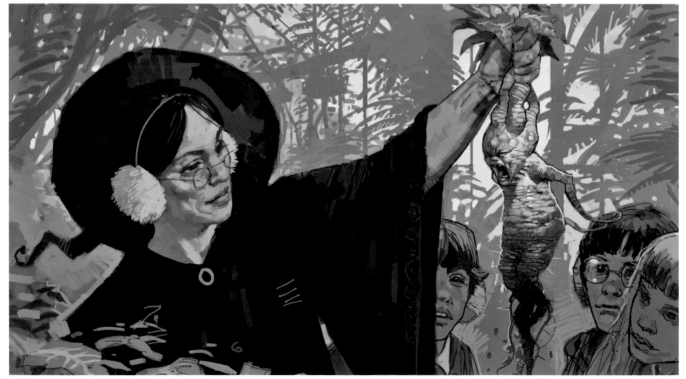

Fig 3.

Page 30. Concept art by Dermot Power for *Harry Potter and the Chamber of Secrets*; Fig 1. Professor Pomona Sprout (Miriam Margoyles) demonstrates the repotting of Mandrakes in her Herbology class in a scene from *Harry Potter and the Chamber of Secrets*; Fig 2. Rows of Mandrakes grow in the Greenhouse; Fig 3. Visual development art by Dermot Power of Professor Sprout's class; Figs 4. & 5. A crying and a quiet Mandrake, with and without leaves, by Dermot Power.

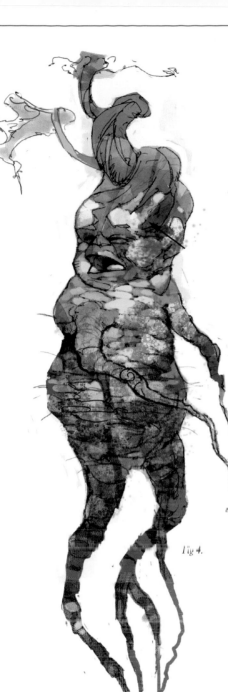

Fig 4.

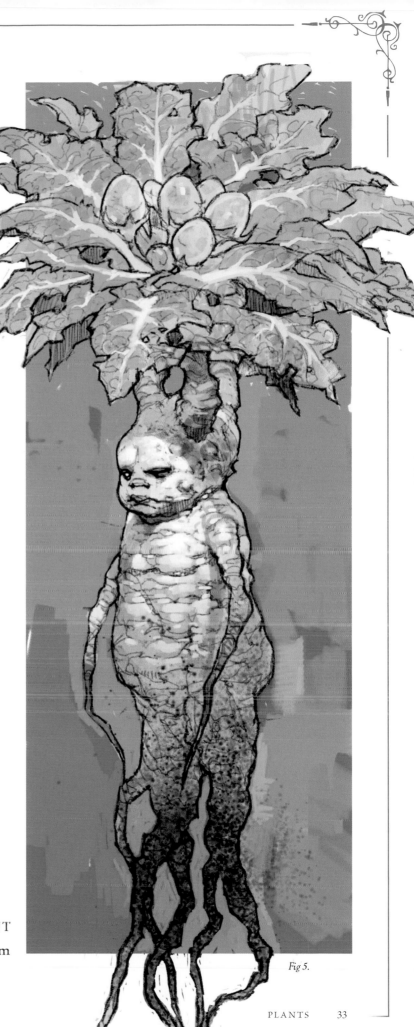

Fig 5.

"*Now, as our Mandrakes are still only seedlings,
their cries won't kill you yet, but they could knock
you out for several hours.*"

—PROFESSOR SPROUT

Harry Potter and the Chamber of Secrets film

Visual development of the Mandrake's leaves for *Harry Potter and the Chamber of Secrets* was based on the real Mandrake plant, so named because it appears to have a trunk and limbs. For the body of the plant, the creature shop designers realized that the look of the baby Mandrakes couldn't be too cute or cuddly as their purpose was to be destroyed in order to make the Petrification cure. So they tried to make them as horrible and unlovable as possible, with wrinkled, screeching faces. More than fifty completely mechanical Mandrakes were created that made up the top halves of their flowerpots, with their movement achieved by one of the most basic special effects techniques—animatronic puppetry. The machinery for the Mandrakes was inside the pots, operated underneath the Greenhouse table by controllers. Once their animatronic action was turned on, the Mandrake would cycle through a series of writhing, wriggling motions that could be sped up or slowed down.

For Professor Sprout, Draco Malfoy, and a few others, Mandrakes were constructed that had similar movement but could be removed from their pots and still move their mouths and appendages, accomplished through radio transmitters.

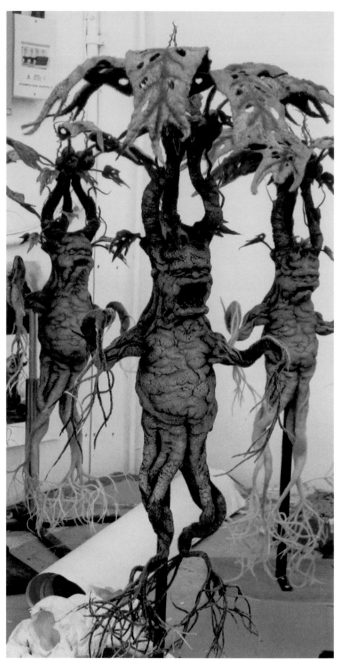

Fig 2.

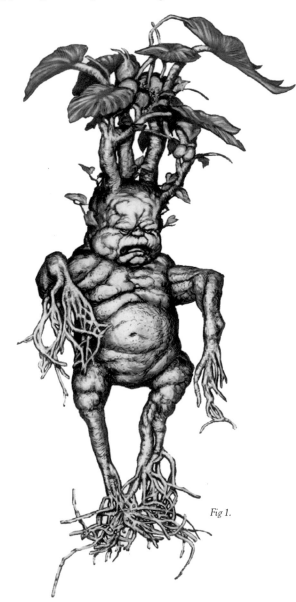

Fig 1.

Figs 1. & 5. Dermot Power studied real Mandrakes to inspire his visual development art for *Harry Potter and the Chamber of Secrets*; Fig 2. The animatronic Mandrakes out of their pots and aloft in the creature shop; Fig 3. Hermione Granger (Emma Watson, center) pulls her Mandrake up and out for repotting in a scene from *Chamber of Secrets*; Fig 4. Close-up of a not-so-adorable animatronic baby Mandrake.

MANDRAKE

✳

I. FILM APPEARANCE: *Harry Potter and the Chamber of Secrets*

II. LOCATION: Greenhouses, Hogwarts

III. DESCRIPTION FROM *HARRY POTTER AND THE CHAMBER OF SECRETS* BOOK, CHAPTER SIX:

"Instead of roots, a small, muddy, and extremely ugly baby popped out of the earth. The leaves were growing right out of his head. He had pale green, mottled skin, and was clearly bawling at the top of his lungs."

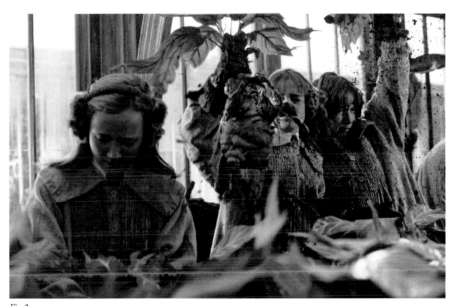

Fig 3.

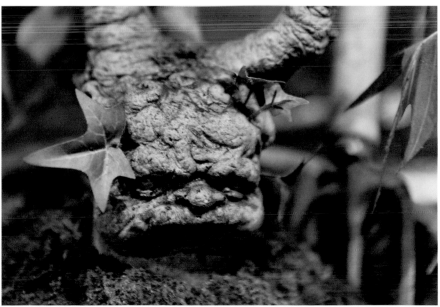

Fig 4.

Fig 5.

Whomping Willow

The Whomping Willow, which grows on the grounds of Hogwarts in the Harry Potter films, is a dangerous, spiteful tree, with branches that can swing, grab, and pound. The tree is rather indestructible—when Ron Weasley and Harry Potter crash the Weasley's flying Ford Anglia into its branches in *Harry Potter and the Chamber of Secrets*, they do more damage to the car than the tree. There is a secret entrance in the Whomping Willow that leads to the Shrieking Shack, as discovered in *Harry Potter and the Prisoner of Azkaban*.

" Not to mention the damage you inflicted on a Whomping Willow that's been on these grounds since before you were born."

—SEVERUS SNAPE
Harry Potter and the Chamber of Secrets film

Fig 1.

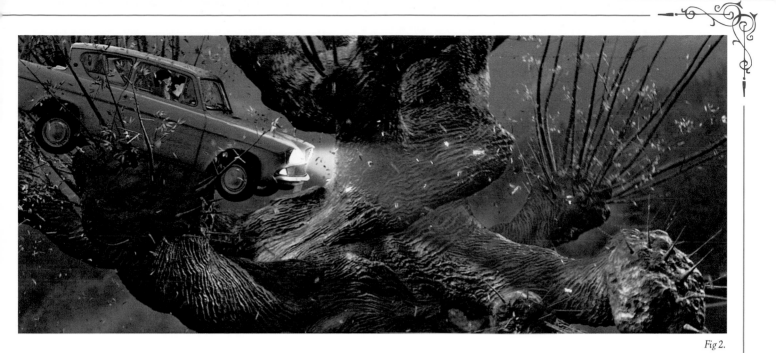

Fig 2.

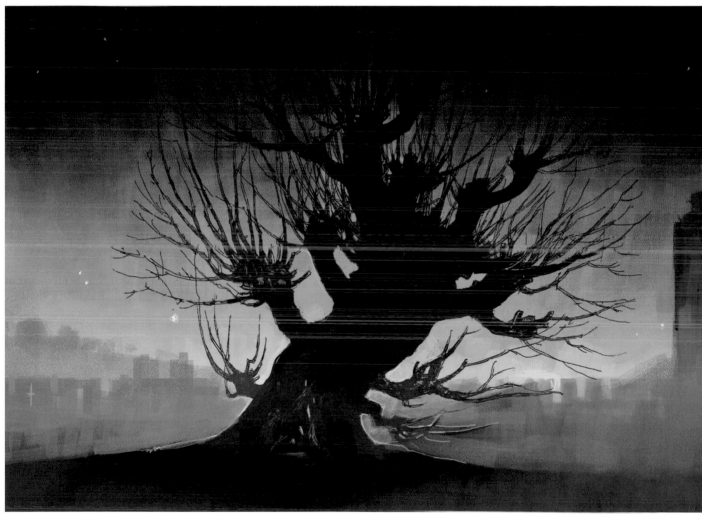

Fig 3.

Fig 1. Concept art of the flying Ford Anglia about to crash into the Whomping Willow by Dermot Power for
Harry Potter and the Chamber of Secrets; Fig 2. The Weasley family's flying car, carrying Harry Potter (Daniel
Radcliffe) and Ron Weasley (Rupert Grint), crashes into the Whomping Willow on the Hogwarts grounds in a
scene from *Chamber of Secrets*; Fig 3. A foggy nighttime silhouette of the Whomping Willow by Dermot Power.

Considering what the Whomping Willow needed to do in *Harry Potter and the Chamber of Secrets*—swallow a car and spit it out—the designers realized the tree had to be big. Very big. As often happened during the Harry Potter films, the idea that the Willow needed to be computer-generated was tabled when the special effects, visual effects, and art departments put their heads and skills together and constructed a tree that grew in two pieces to the height of eighty-five feet. First, a hydraulic-motion base was built, and then it was hidden by the rubber-covered trunk of the tree. The car fit into this and could be waved around. Then hydraulically operated branches were added to twist and grasp around the car. The trunk and branches were controlled by a miniature version of the tree that was a waldo device. The waldo contained actuators that sent an electric signal through a computer to corresponding actuators in the full-size Willow, which then imitated the waldo's movement.

For *Harry Potter and the Prisoner of Azkaban*, the tree was moved from its location near the Training Grounds to an area closer to the castle. It was also downsized, as the sequence of the black dog grabbing Ron and dragging him inside took place at the base of the tree. The Whomping Willow was no less dangerous, though, grabbing Harry and Hermione Granger with whiplike branches and flying them around through the air. Motion-controlled rigs swung Daniel Radcliffe (Harry) and Emma Watson (Hermione) around in a sequence that had been previsualized in an animatic, which is a digitally created storyboard. The rigs' movements were imported into a computer, which converted that movement into flailing, grabbing branches. For any action deemed too dangerous, 3D digital models of Radcliffe and Watson stood in for the actors.

Fig 1.

Fig 2.

FAST FACTS
WHOMPING WILLOW

✳

I. FIRST FILM APPEARANCE: *Harry Potter and the Chamber of Secrets*

II. ADDITIONAL FILM APPEARANCES: *Harry Potter and the Prisoner of Azkaban, Harry Potter and the Goblet of Fire, Harry Potter and the Deathly Hallows – Part 2*

III. LOCATION: Hogwarts grounds

IV. DESCRIPTION FROM *HARRY POTTER AND THE CHAMBER OF SECRETS* BOOK, CHAPTER FIVE:

"[T]he windshield was now trembling under a hail of blows from knuckle-like twigs and a branch as thick as a battering ram was pounding furiously on the roof . . ."

Fig 1. The Ford Anglia sits at the base of the Whomping Willow, post-crash, in concept art by Dermot Power for *Harry Potter and the Chamber of Secrets*; Fig 2. The Ford Anglia begins its descent onto the Hogwarts grounds in artwork by Dermot Power for *Chamber of Secrets*; Autumn and winter views of the Whomping Willow by Dermot Power (Fig 3.) and Adam Brockbank (Fig. 4) for *Harry Potter and the Prisoner of Azkaban.*

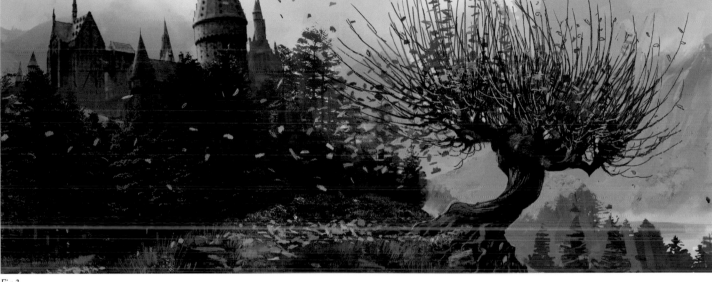

Fig 3.

Fig 4.

Mimbulus Mimbletonia

In *Harry Potter and the Order of the Phoenix*, Neville Longbottom brings a *Mimbulus mimbletonia* to school. This lumpy gray plant wriggles and pulsates, and squirts out Stinksap when irritated. Neville obviously takes good care of it; the plant is still present during a scene in *Harry Potter and the Deathly Hallows – Part 2*, in the Room of Requirement, where it sits near the wireless transmitter.

The movement of the *Mimbulus mimbletonia* was animated in a similar way to the Mandrakes. A metal skeletal structure inside of the prop would twist and scrunch via radio-controlled transmitters. For simple motions such as these, the transmitter would be manually controlled. Creatures with more intricate, complicated movements would be activated via a computer program.

In a scene in the Gryffindor common room deleted from *Harry Potter and the Order of the Phoenix*, Neville probes and prods at the plant. At one point he pokes the wrong place, and the plant spurts green sludge all over him. Director David Yates wanted Matthew Lewis (Neville Longbottom) to not react as he was drenched, to remain motionless. The actor admitted it got harder and harder not to flinch, as he knew what was about to happen. Lewis had to change his wardrobe and wash up between each take.

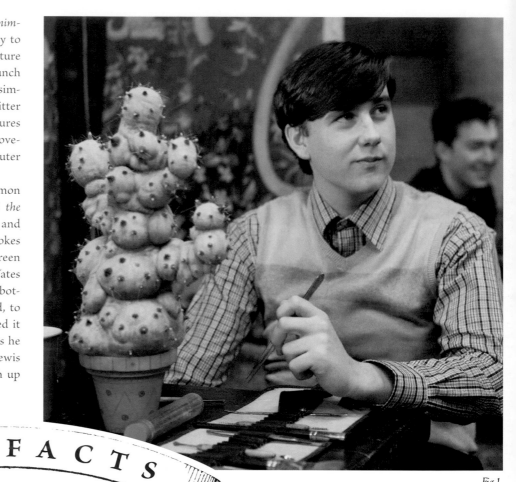

Fig 1.

FAST FACTS

MIMBULUS MIMBLETONIA

✴

I. FIRST FILM APPEARANCE: *Harry Potter and the Order of the Phoenix*

II. ADDITIONAL FILM APPEARANCES:
Harry Potter and the Deathly Hallows – Part 2

III. LOCATION: Gryffindor common room, Room of Requirement

IV. DESCRIPTION FROM *HARRY POTTER AND THE ORDER OF THE PHOENIX* BOOK, CHAPTER TEN:

"[Neville] . . . pulled out what appeared to be a small gray cactus in a pot except that it was covered with what looked like boils rather than spines."

Fig 1. Neville Longbottom (Matthew Lewis) attends his *Mimbulus mimbletonia* in the Gryffindor common room in a deleted scene from *Harry Potter and the Order of the Phoenix*; Fig 2. Plant portrait by Rob Bliss.

Fig 2.

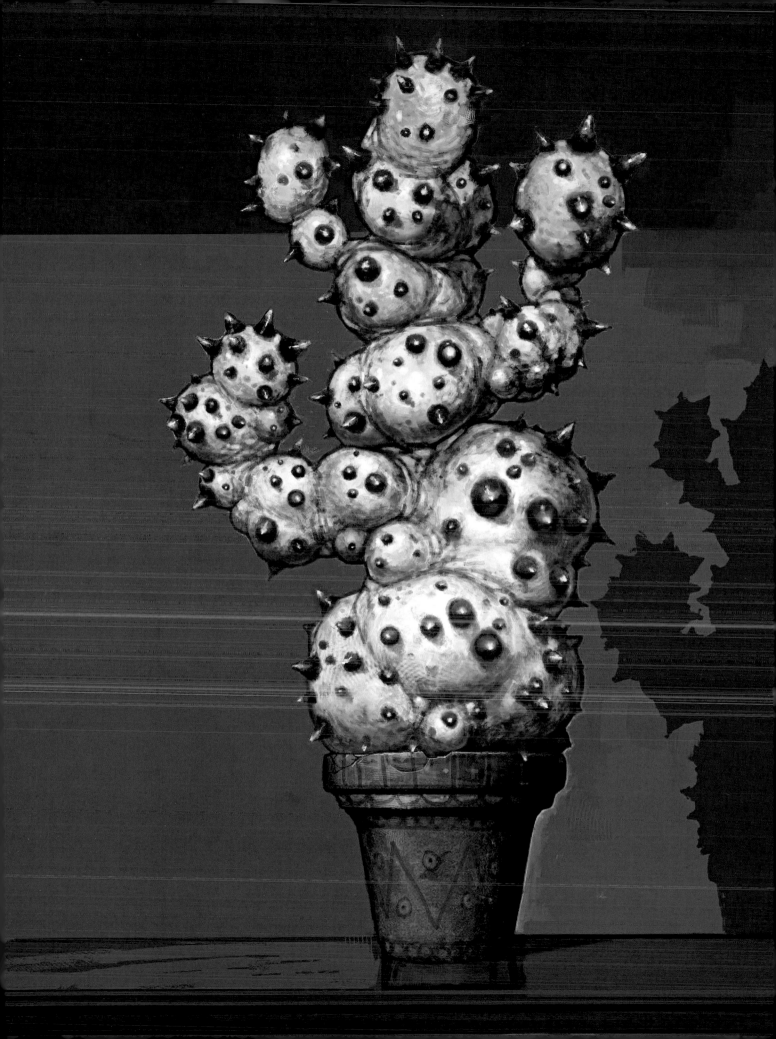

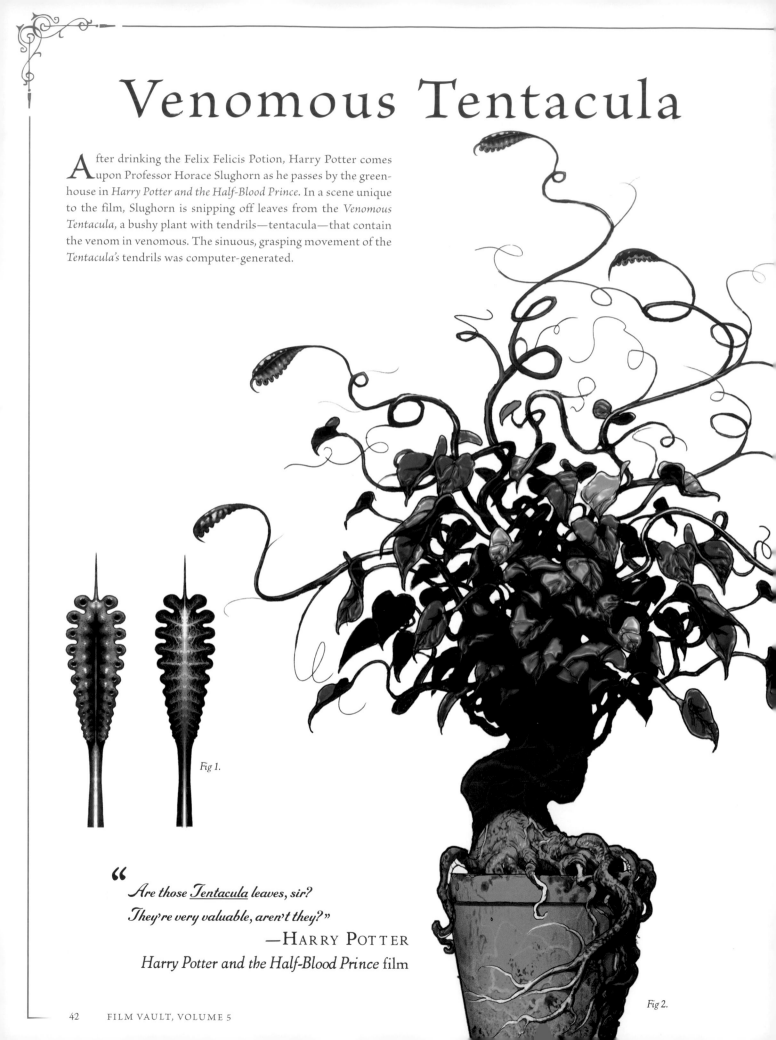

Venomous Tentacula

After drinking the Felix Felicis Potion, Harry Potter comes upon Professor Horace Slughorn as he passes by the green-house in *Harry Potter and the Half-Blood Prince*. In a scene unique to the film, Slughorn is snipping off leaves from the *Venomous Tentacula*, a bushy plant with tendrils—tentacula—that contain the venom in venomous. The sinuous, grasping movement of the *Tentacula's* tendrils was computer-generated.

Fig 1.

" *Are those Tentacula leaves, sir?*
They're very valuable, aren't they?"
—HARRY POTTER
Harry Potter and the Half-Blood Prince film

Fig 2.

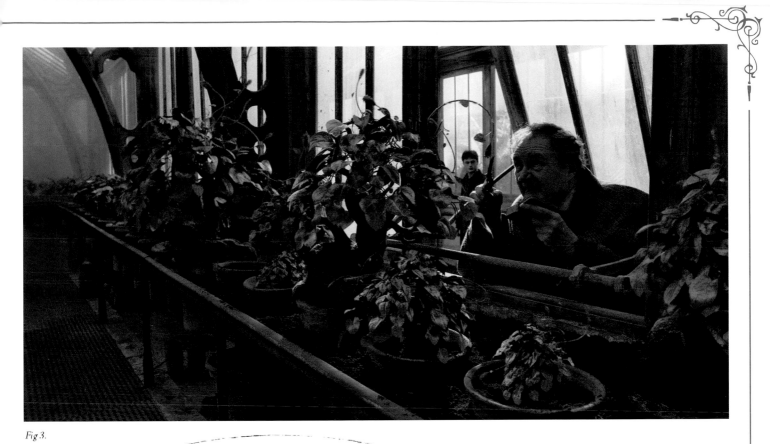

Fig 3.

F A S T F A C T S

VENOMOUS
TENTACULA

✳

I. FILM APPEARANCE: *Harry Potter and the Half-Blood Prince*

II. LOCATION: Herbology Greenhouse

III. DESCRIPTION FROM *HARRY POTTER
AND THE CHAMBER OF SECRETS* BOOK, CHAPTER SIX:

*"[Professor Sprout] gave a sharp slap to a spiky, dark red plant
as she spoke, making it draw in the long feelers that had
been inching sneakily over her shoulder."*

Fig 1. Samples of the grasping tentacles of the *Venomous Tentacula*, and (Fig 2.) the plant itself, by Adam Brockbank for *Harry Potter and the Half-Blood Prince*; Fig 3. Harry Potter (Daniel Radcliffe, background) comes upon Slughorn (Jim Broadbent) surreptitiously cutting off *Tentacula* leaves in a scene from *Half-Blood Prince*; Fig 4. Director David Yates demonstrates to actor Jim Broadbent (Horace Slughorn) how the *Venomous Tentacula* will appear in the Greenhouse.

Fig 4.

❝ *My own interests are . . . purely academic,
of course.❞*

—HORACE SLUGHORN
Harry Potter and the Half-Blood Prince film

Dirigible Plum

In the film *Harry Potter and the Deathly Hallows – Part 1*, Dirigible Plums are depicted growing upside down amid the dark shiny leaves of their bushy tree, as observed by Harry Potter, Hermione Granger, and Ron Weasley when they see the plant beside Xenophilius Lovegood's house in *Deathly Hallows – Part 1*. Orange-colored, they are shaped more like a radish than a plum. They are also capable of floating away like a tiny helium-filled blimp. In *Harry Potter and the Order of the Phoenix*, Luna Lovegood wears a pair of Dirigible Plum–shaped earrings. Evanna Lynch, who played Luna, crafted the radish-shaped earrings, among other jewelry she created for her character throughout the films.

> *"Keep off the Dirigible Plums?"*
> —RON WEASLEY, READING
> A SIGN OUTSIDE OF THE
> LOVEGOODS' HOUSE
> *Harry Potter and the Deathly Hallows –*
> *Part 1* film

Fig 1.

Fig 2.

Fig 3.

Figs 1. & 3. Specimen studies of the Dirigible Plum by Adam Brockbank for *Harry Potter and the Deathly Hallows – Part 1*; Fig 2. The Dirigible Plum bush in front of the Lovegoods' house on the set of *Deathly Hallows – Part 1*; Fig 4. The same view, with Hermione, Harry, and Ron, envisioned in concept art by Adam Brockbank.

FAST FACTS

DIRIGIBLE PLUM

✴

I. FIRST FILM APPEARANCE AS JEWELRY:
Harry Potter and the Order of the Phoenix

II. FIRST FILM APPEARANCE AS PLANT:
Harry Potter and the Deathly Hallows – Part 1

III. LOCATION: Xenophilius Lovegood's house

IV. DESCRIPTION FROM *HARRY POTTER AND THE DEATHLY HALLOWS* BOOK, CHAPTER TWENTY:
"The zigzagging path leading to the front door was overgrown with a variety of odd plants, including a bush covered in an orange radishlike fruit Luna sometimes wore as earrings."

Fig 4.

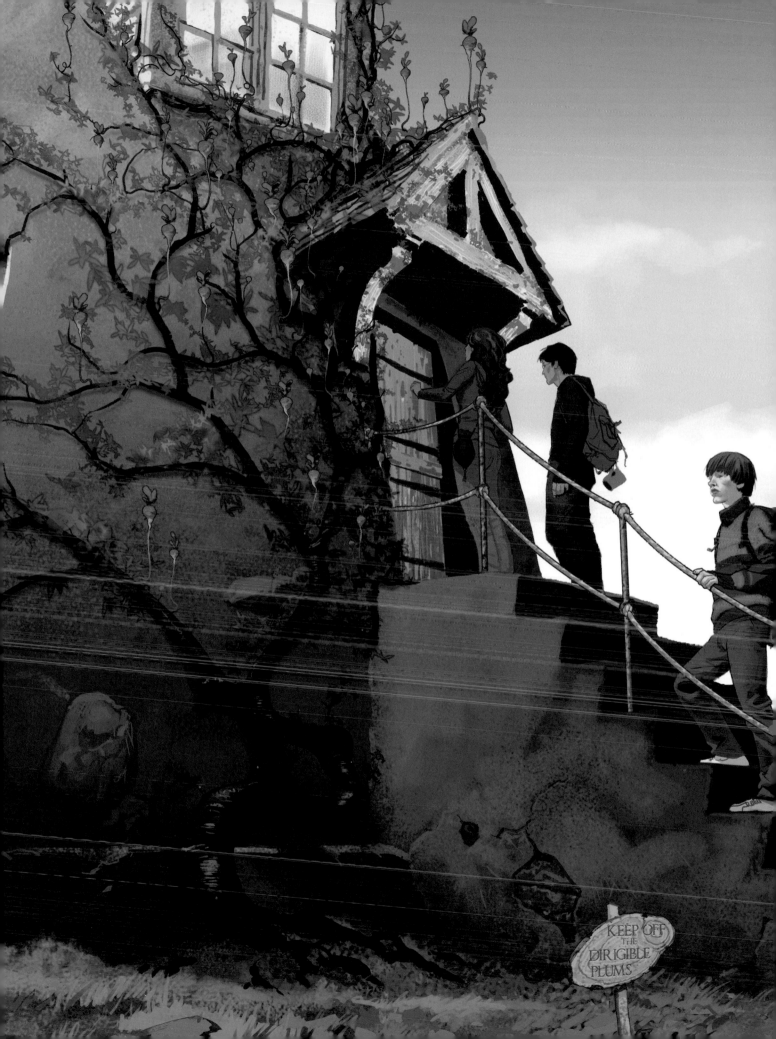

KEEP OFF
THE
DIRIGIBLE
PLUMS

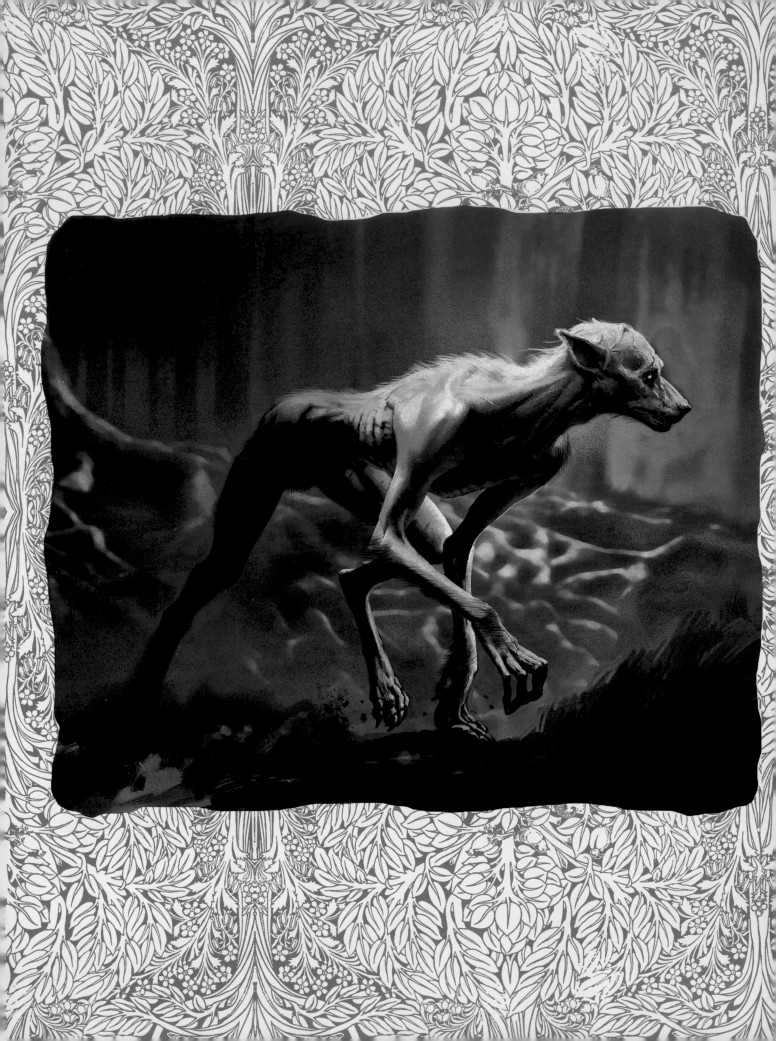

CHAPTER THREE

SHAPESHIFTERS

The wizarding world brought to life in the Harry Potter films is populated by several shapeshifting beings. There are wizards who have studied a type of magic in which they can choose to transform themselves into an animal; they are called Animagi. Then there are wizards who have been bitten by a werewolf and are given no choice but to transform. The Boggart is a shapeshifting creature whose true form is unknown—it changes into its viewer's greatest fear.

Animagus

In the world of Harry Potter, an Animagus is a witch or wizard who can choose at will to turn him- or herself into an animal. There are some instances where the Animagus form of a wizard may display a recognizable mark, physical or nonphysical, that can identify them, and the Patronus of an Animagus is often the same animal species.

Fig 1.

Page 46. The werewolf form of Remus Lupin lopes through the Forbidden Forest in concept art by Adam Brockbank for *Harry Potter and the Prisoner of Azkaban*; Fig 1. Professor McGonagall in her Animagus form in a scene from *Harry Potter and the Sorcerer's Stone*, as played by Mrs. P. Head; Fig 2. The five-part transformation of Scabbers the rat into Peter Pettigrew in artwork by Rob Bliss for *Harry Potter and the Prisoner of Azkaban*; Fig 3. Professor McGonagall's Animagus form watches her Transfiguration class for first years in a scene from *Sorcerer's Stone*; Fig 4. Digital construct of McGonagall transforming into her Animagus form.

"
Harry, it's a trap. He's the dog. He's an Animagus!"

—RON WEASLEY

Harry Potter and the Prisoner of Azkaban film

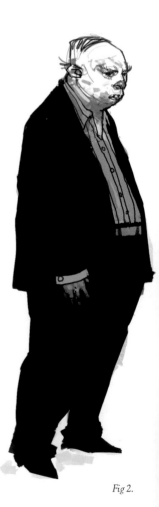

Fig 2.

MINERVA McGONAGALL

The Animagus form of Professor Minerva McGonagall is a gray tabby cat. This feline form of the professor allows her to covertly observe Harry Potter's relatives, the Dursleys, in *Harry Potter and the Sorcerer's Stone*. McGonagall also uses her Animagus form to monitor her first year's Transfiguration class.

Professor McGonagall's Animagus form was played by a tabby cat named Mrs. P. Head. No additional makeup or computer effects were needed, as the cat already had the required "spectacle" markings. When Harry and Ron Weasley enter her Transfiguration class in the film version of *Sorcerer's Stone*, McGonagall's Animagus form leaps from her desk and morphs into the human McGonagall. For this action, a trainer underneath the desk held the end of an invisible safety harness that was settled on the accomplished animal actor. Sitting directly above the trainer, Mrs. P. Head was given a cue to spring off the desk, and the safety harness was released at the same time. This film segment was then composited with a computer-generated transition from feline to professor.

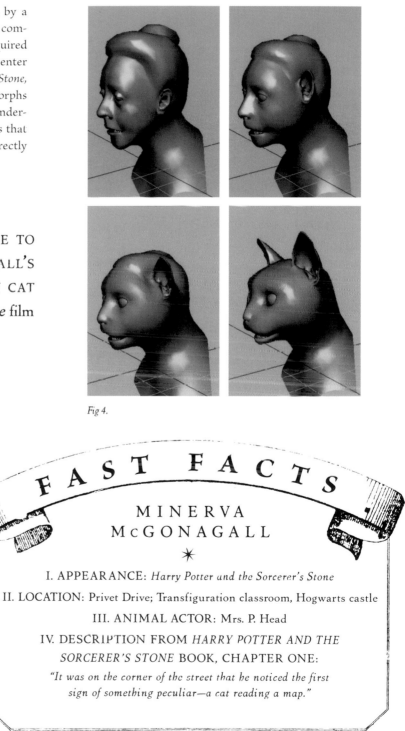

Fig 4.

> **"***That was bloody brilliant!***"**
>
> —RON WEASLEY IN RESPONSE TO PROFESSOR McGONAGALL'S TRANSFORMATION FROM A TABBY CAT
> *Harry Potter and the Sorcerer's Stone* film

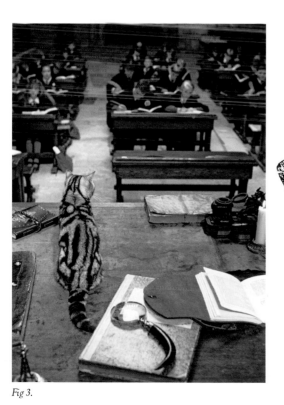

Fig 3.

FAST FACTS

MINERVA McGONAGALL

✳

I. APPEARANCE: *Harry Potter and the Sorcerer's Stone*

II. LOCATION: Privet Drive; Transfiguration classroom, Hogwarts castle

III. ANIMAL ACTOR: Mrs. P. Head

IV. DESCRIPTION FROM *HARRY POTTER AND THE SORCERER'S STONE* BOOK, CHAPTER ONE:

"It was on the corner of the street that he noticed the first sign of something peculiar—a cat reading a map."

SIRIUS BLACK

Sirius Black's Animagus form is that of a large black dog his friends call "Padfoot," first seen in *Harry Potter and the Prisoner of Azkaban*. Sirius, James Potter, and Peter Pettigrew studied to become Animagi when they discovered that fellow Gryffindor Remus Lupin was a werewolf. Sirius and James, who turned into a stag called "Prongs," were able to control Remus during his monthly transformations. Sirius takes advantage of his Animagus form in *Harry Potter and the Order of the Phoenix* to stealthily see Harry Potter off to Hogwarts.

In *Harry Potter and the Prisoner of Azkaban*, Padfoot, who is initially mistaken for the Grim, was a computer-generated Animagus. The filmmakers brought in a show dog named Fern (full name: Champion Kilbourne Darling), a Kilbourne deerhound, as reference for the part. Fern was fitted with pointed ears and learned to jump ramps to perform the stunts needed for the character's digital template. Fern was backed up by another Kilbourne deerhound named Cleod. An award-winning show dog (full name: Champion Kilbourne MacLeod), Cleod's normally gray fur was darkened with a temporary rinsible black dye.

Sirius's Animagus form was recast for his appearance in *Harry Potter and the Order of the Phoenix*. This time he was played by a Scottish deerhound named Quinn, who was a rescue dog. Quinn's trainer describes him as being a little stubborn, but with a fun-loving nature.

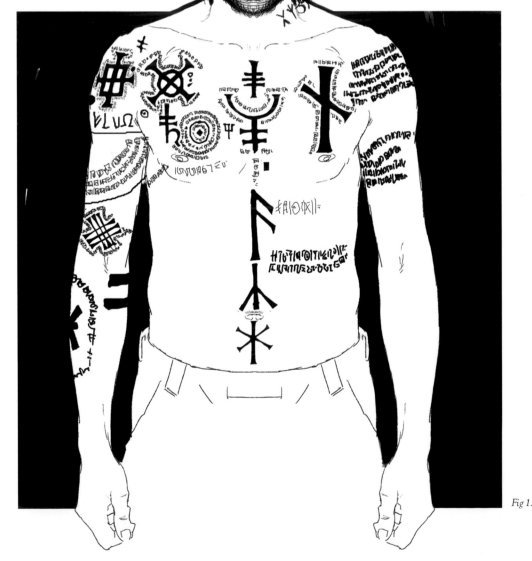

Fig 1.

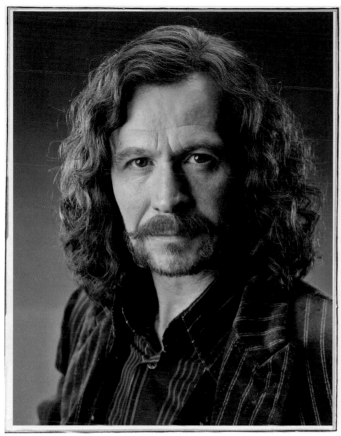

Fig 2.

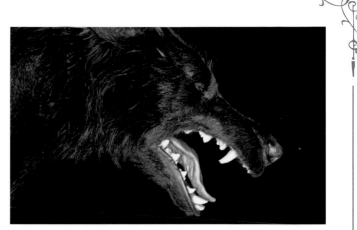

Fig 3.

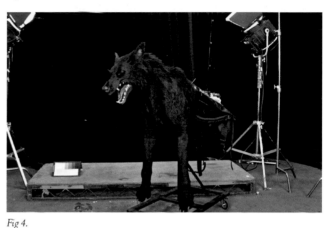

Fig 4.

" *Normally I have a very sweet disposition as a dog. In fact, more than once, James suggested that I make the change permanent. The tail I could live with, but the fleas, they're murder.*"

— SIRIUS BLACK

Harry Potter and the Prisoner of Azkaban film

Fig 5.

FAST FACTS

SIRIUS BLACK

✴

I. FIRST FILM APPEARANCE: *Harry Potter and the Prisoner of Azkaban*

II. ADDITIONAL FILM APPEARANCE:
Harry Potter and the Order of the Phoenix

III. LOCATIONS: Privet Drive, Hogwarts, King's Cross Station

IV. ANIMAL ACTORS:
Fern, Cleod (*Prisoner of Azkaban*), Quinn (*Order of the Phoenix*)

V. DESCRIPTION FROM *HARRY POTTER AND THE PRISONER OF AZKABAN* BOOK, CHAPTER SEVENTEEN:
"Something was bounding toward them, quiet as a shadow— an enormous, pale-eyed, jet-black dog."

Fig 1. Rob Bliss charts the locations of Sirius Black's alchemic tattoos; Fig 2. Gary Oldman (Sirius Black) in a publicity shot for *Harry Potter and the Order of the Phoenix*; Figs 3. & 4. A model of Sirius's Animagus form; Fig 5. Sirius Black's robe for *Order of the Phoenix*, sketched by Mauricio Carneiro, based on concepts by costume designer Jany Temime.

PETER PETTIGREW

During the events of *Harry Potter and the Prisoner of Azkaban*, Harry Potter learns that his father, James, was close friends with Sirius Black, Remus Lupin, and Peter Pettigrew, who attended Hogwarts together. Pettigrew became an Animagi, along with James and Sirius, transforming into a rat they called "Wormtail." When Pettigrew betrays James and Lily Potter to Voldemort, he goes into hiding as the Weasleys' family pet, Scabbers.

The Animagus form of Peter Pettigrew in *Harry Potter and the Prisoner of Azkaban* was played mainly by the rat named Dex, in addition to several animatronic rat versions. For the transformation from the rat to Peter Pettigrew in the Shrieking Shack, a combination of real and animatronic rats was used. When Sirius Black first reveals that the rat Ron Weasley is holding is not Scabbers but Pettigrew in his Animagus form, actor Rupert Grint (Ron) is holding Dex, but it is an animatronic version of Wormtail that is snatched out of his hands by Gary Oldman (Sirius).

Dex was trained to run from a point A to a point B, an example being when—in an effort to escape—Wormtail runs over the piano and across the floor in the Shrieking Shack. Any other occasion where the animal would drop, be thrown, be grabbed, etc., was enacted by an animatronic or digital version.

Unlike Professor McGonagall and Sirius Black, Peter Pettigrew exhibits obvious ratlike features in his human form. The makeup team matched the color of the rat's fur to the wigs created for Timothy Spall, the actor who played the human version of Peter Pettigrew, and gave him ratlike teeth and nails.

Fig 1.

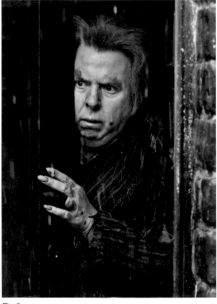

Fig 2.

"*We thought he was our friend.*"
—REMUS LUPIN
Harry Potter and the
Prisoner of Azkaban film

PETER PETTIGREW

✦

I. FILM APPEARANCE AS WORMTAIL:
Harry Potter and the Prisoner of Azkaban

II. LOCATION: Shrieking Shack

III. ANIMAL ACTOR: Dex, plus other live and animatronic rats

IV. DESCRIPTION FROM *HARRY POTTER AND THE PRISONER OF AZKABAN* BOOK, CHAPTER ELEVEN:
"Scabbers, once so fat, was now very skinny; patches of fur seemed to have fallen out too."

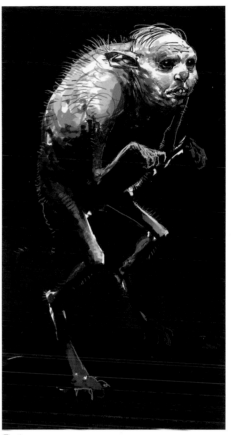

Fig 4.

"*Black was vicious, he didn't kill Pettigrew; he destroyed him. A finger. That's all that was left—a finger!*"
—CORNELIUS FUDGE, MINISTER FOR MAGIC
Harry Potter and the Prisoner of Azkaban film

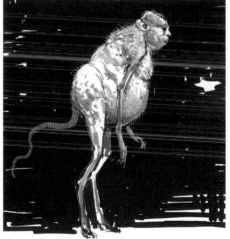

Fig 5.

Fig 3.

Fig 1. Pettigrew's decidedly rodential features are apparent in artwork by Rob Bliss; Fig 2. Peter Pettigrew (Timothy Spall) in *Harry Potter and the Half-Blood Prince*; Fig 3. Rob Bliss portrays Peter Pettigrew as he transforms into Wormtail the rat in *Harry Potter and the Prisoner of Azkaban*; Figs 4. & 5. Full-body studies combining the rat and human forms of Peter Pettigrew by Rob Bliss.

Boggart

The true shape of a Boggart is unknown, as a Boggart changes its shape to that of the viewer's most horrible fear. In *Harry Potter and the Prisoner of Azkaban*, Defense Against the Dark Arts Professor Remus Lupin instructs his third-year students how to cast the *Riddikulus* charm to repel such a creature. Lupin also uses a Boggart in a private lesson in the same film to teach Harry Potter how to cast the Patronus charm in defense against a Dementor—Harry's worst fear.

Neville Longbottom is first to practice the *Riddikulus* charm in *Harry Potter and the Prisoner of Azkaban*, redressing Professor Snape in grandmother Longbottom's bird-topped hat and tweedy skirt ensemble. Ron imagines roller skates on the eight legs of an Acromantula. Pavarti transforms a cobra into a jack-in-the-box. But when Harry sees a Dementor, Lupin intercedes. Lupin's worst fear is a full moon creeping out of a shadowy sky, which he turns into a deflating white balloon, all effects created in the computer. Because an actual Boggart is never seen, the visual effects designers were tasked with creating the transition from the scary version to the laughable version. Director Alfonso Cuarón did not want this to be either in a solid form nor a transparent one. So, they interpreted it as a swirling tornado of the Boggart's fearful and funny forms.

> " *Boggarts are shape-shifters. They take the shape of whatever a particular person fears the most.*"
> —HERMIONE GRANGER
> *Harry Potter and the Prisoner of Azkaban* film

Fig 1.

Figs 1. & 2. Concept art of the spider before and after the charm by Wayne Barlowe for *Harry Potter and the Prisoner of Azkaban*; Fig 3. Harry (Daniel Radcliffe) practices the *Riddikulus* charm on a menacing jack-in-the-box Boggart in a scene from *Prisoner of Azkaban*; Fig 4. Neville Longbottom imagines the Professor Snape (Alan Rickman) form of the Boggart in his grandmother's clothing in the same scene.

Fig 2.

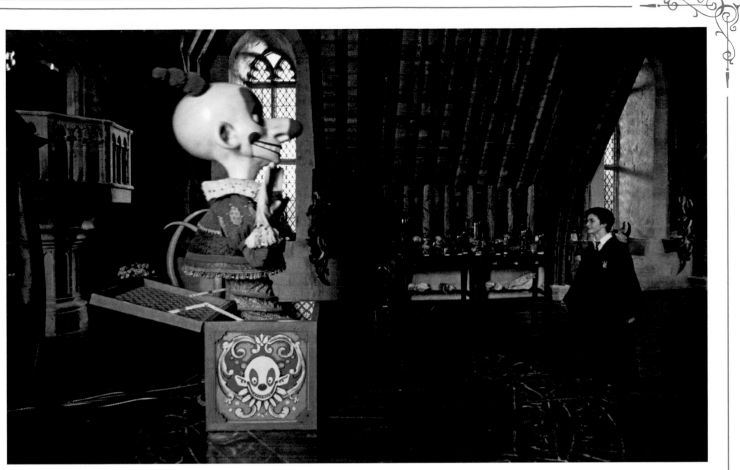

Fig 3.

Fig 4.

FAST FACTS

BOGGART

✶

I. FILM APPEARANCE (THOUGH NOT ITS TRUE APPEARANCE):
Harry Potter and the Prisoner of Azkaban

II. LOCATION: Defense Against the Dark Arts classroom

III. DESCRIPTION FROM *HARRY POTTER AND THE PRISONER OF AZKABAN* BOOK, CHAPTER SEVEN:
"Nobody knows what a Boggart looks like when he is alone, but when I let him out he will immediately become whatever each of us most fears." —Professor Remus Lupin

"Luckily, a very simple charm exists to repel a Boggart. Let's practice it now. Now, without wands, please. After me: Riddikulus!"

—REMUS LUPIN
Harry Potter and the Prisoner of Azkaban film

Werewolf

While an Animagus chooses to turn into their animal form, like Professor McGonagall in *Harry Potter and the Sorcerer's Stone* and Peter Pettigrew in *Harry Potter and the Prisoner of Azkaban*, a werewolf has no choice but to transform at the rising of the full moon.

Fig 2.

Fig 1.

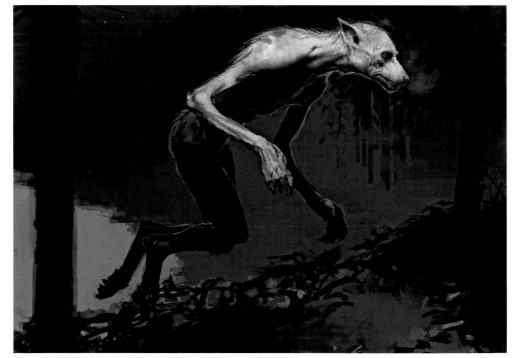

Fig 3.

Different interpretations of Professor Remus Lupin's werewolf form for *Harry Potter and the Prisoner of Azkaban* were considered in concept art by Rob Bliss (Figs 1., 2., 4. & 5.) and Adam Brockbank (Fig 3.); Figs 6.—9. The transformative stages of Lupin into a werewolf were also explored in studies by Adam Brockbank.

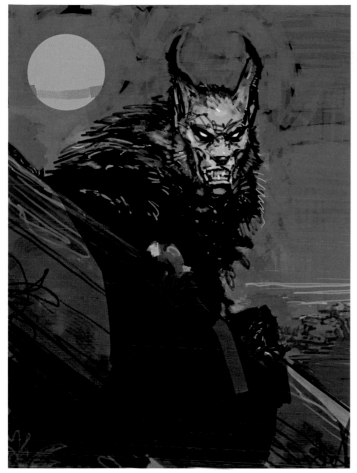

Fig 4.

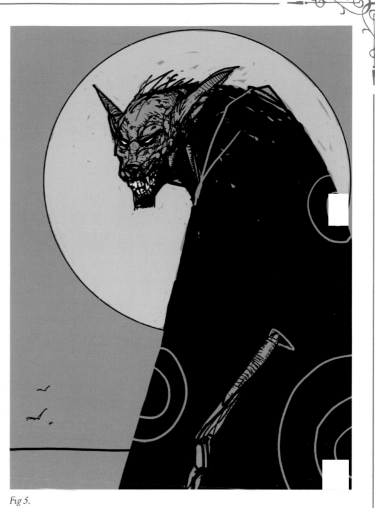

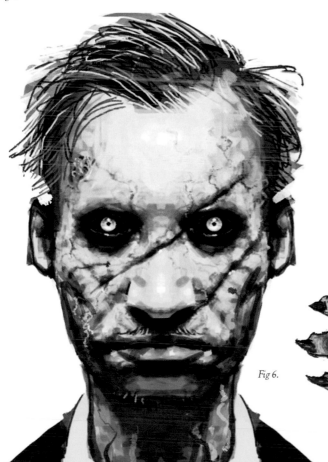

Fig 6.

Fig 7.

Fig 8.

Fig 9.

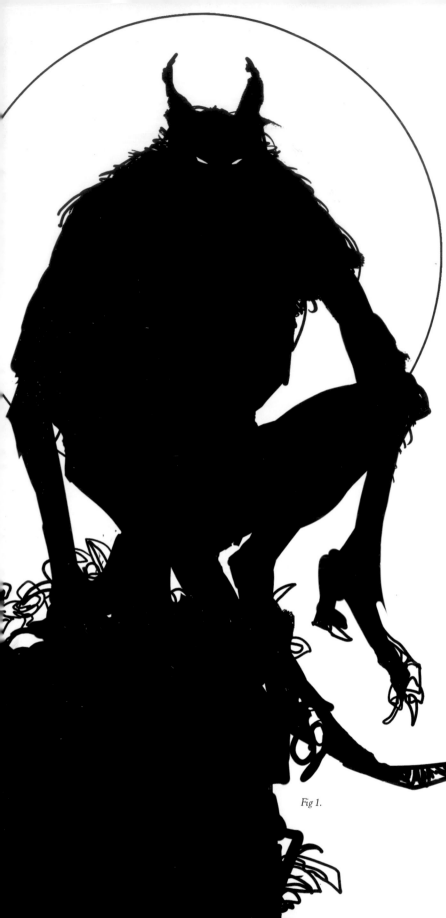

Fig 1.

Fig 2.

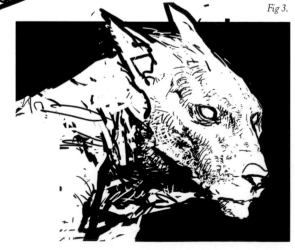

Fig 3.

> "*As an antidote to your ignorance, and on my desk by Monday morning, two rolls of parchment on the werewolf, with particular emphasis on recognizing it.*"
>
> —SEVERUS SNAPE
>
> *Harry Potter and the Prisoner of Azkaban* film

Figs 1.—4. Werewolf concept studies by Rob Bliss for *Harry Potter and the Prisoner of Azkaban*.

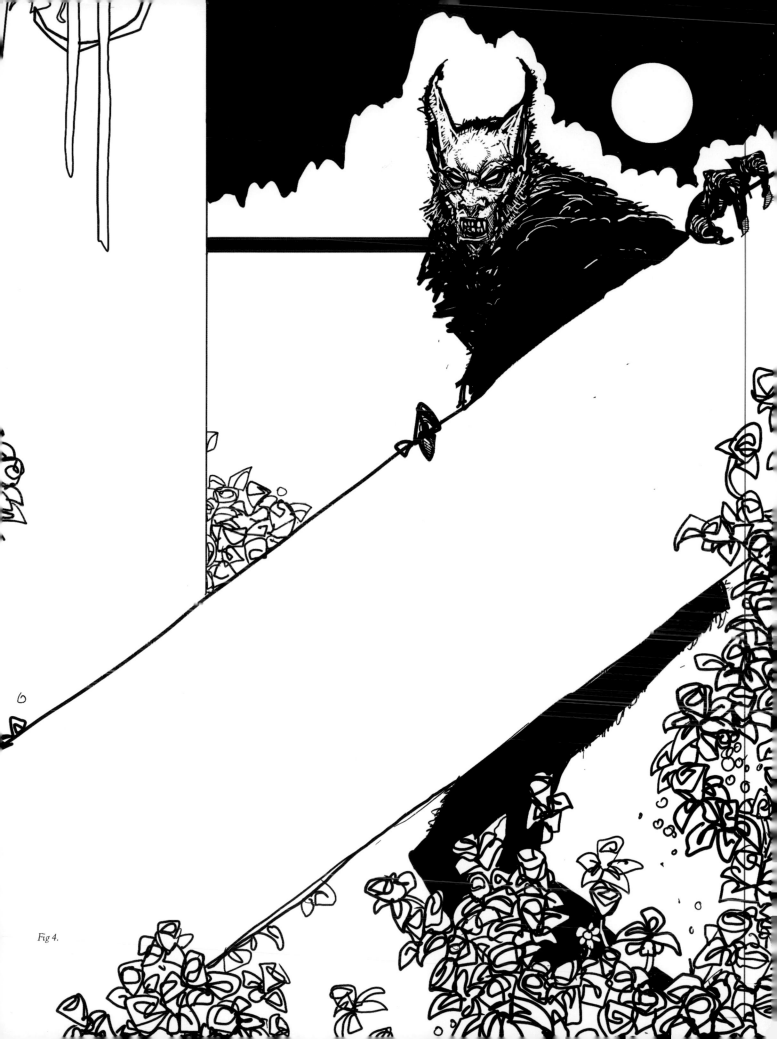

Fig 4.

REMUS LUPIN

It is established in *Harry Potter and the Prisoner of Azkaban* that Remus Lupin, while a child, was bitten by the werewolf Fenrir Greyback. As an adult, he is able to take Wolfsbane Potion to control his condition, but he still struggles with the shame and weight of his secret, which the filmmakers brought out through costume and makeup.

With more than one hundred werewolf transformations filmed throughout the history of cinema prior to Remus Lupin's, the visual development artists for *Harry Potter and the Prisoner of Azkaban* were eager to give this iconic character a fresh approach. Inspiration came from depicting Lupin's condition as an illness. To that end, his pallid face and scarred body mark his struggle against the affliction, and his gray, shabby clothing add to the idea that he has faced much hardship and paucity.

Lupin's werewolf form isn't meant to be as scary as conventional movie werewolves; there is a gravity and sadness about him. His makeup design is lupine but retains some of his humanity. Lupin's werewolf form is thin and disfigured, almost emaciated, with long limbs and a hunched back. One significant change from most movie werewolves is that Lupin is relatively hairless.

The creature designers began with the hope that they would be able to achieve the werewolf transformation practically, with prosthetics and animatronics. They decided to sculpt the werewolf they wanted without worrying how they would install someone to control the sculpt. The result was an extraordinary creature that was extremely tall (seven feet) and extremely thin, and would require a performer with a unique skill set who could fit inside. A kick boxer and a dancer were cast and trained for several months wearing three-foot-tall reverse stilts to give them the necessary height and stride. When they were brought to the actual set featuring the Whomping Willow, it became apparent that the performers could not achieve the same effect they had in rehearsal. The costume was tight and restrictive, not allowing the creature to be as athletic as desired. Additionally, as the scene's set was an undulating hillside strewn with rocks and tall grasses, the performers labored for balance and could not move as quickly across the terrain.

Actor David Thewlis (Remus Lupin) worked with a choreographer to create the sad, twisted body language for the transformation, and was subjected to all sorts of physical effects, including the werewolf makeup. Up until Lupin completes his transformation, practical and makeup effects were combined to span the transition from human to werewolf. Thewlis was fitted with several stages of prosthetics that changed his eyes, teeth, and hands. Other effects included a cable-controlled piece under the back of his coat, which expanded to rip apart the material, and bladders on his neck that inflated. Visual tricks included a cutaway shot of the actor's fingernails growing longer and his feet elongating and stepping out of his shoes. "We shot the scene over four or five days," Thewlis remembers. "I only spent one day in the full makeup before the character became a wholly CG creature. Because of these difficulties, it was determined that the final werewolf seen on-screen would need to be created by computer.

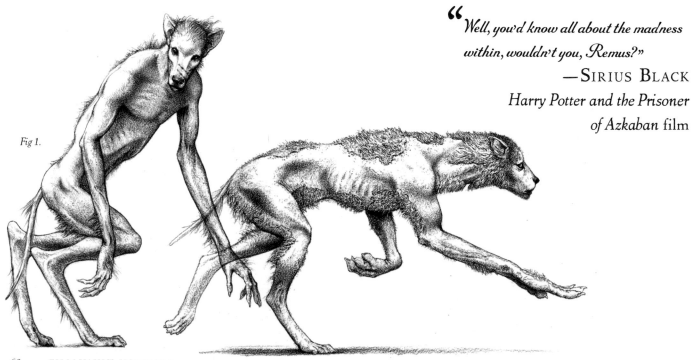

Fig 1.

“*Well, you'd know all about the madness within, wouldn't you, Remus?*”
—SIRIUS BLACK
Harry Potter and the Prisoner of Azkaban film

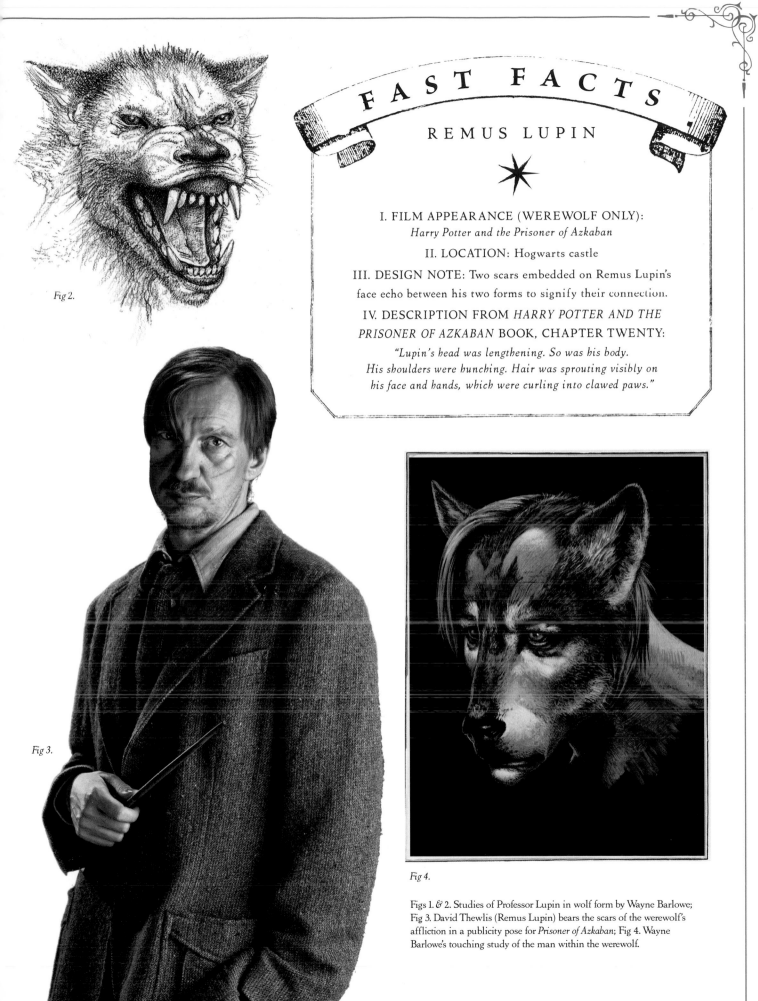

Fig 2.

FAST FACTS

REMUS LUPIN

✦

I. FILM APPEARANCE (WEREWOLF ONLY):
Harry Potter and the Prisoner of Azkaban

II. LOCATION: Hogwarts castle

III. DESIGN NOTE: Two scars embedded on Remus Lupin's
face echo between his two forms to signify their connection.

IV. DESCRIPTION FROM *HARRY POTTER AND THE
PRISONER OF AZKABAN* BOOK, CHAPTER TWENTY:
*"Lupin's head was lengthening. So was his body.
His shoulders were hunching. Hair was sprouting visibly on
his face and hands, which were curling into clawed paws."*

Fig 3.

Fig 4.

Figs 1. & 2. Studies of Professor Lupin in wolf form by Wayne Barlowe;
Fig 3. David Thewlis (Remus Lupin) bears the scars of the werewolf's
affliction in a publicity pose for *Prisoner of Azkaban*; Fig 4. Wayne
Barlowe's touching study of the man within the werewolf.

FENRIR GREYBACK

In the Harry Potter films, Fenrir Greyback is a werewolf who so delights in his beastly nature that he is slowly becoming a hybrid of wolf and man. Greyback is involved in the attacks on Diagon Alley, Hogwarts' Astronomy Tower, and The Burrow in *Harry Potter and the Half-Blood Prince*, and participates in the battle of Hogwarts in *Deathly Hallows – Parts 1* and *2*.

There is an essential difference between the werewolves Remus Lupin and Fenrir Greyback: Greyback enjoys his transformation so much that he retains many of his wolfish characteristics even when he is in human form. Similar to the centaurs and merpeople, there is no obvious demarcation line in Greyback between wolf and man. The designers brought the fine down of a wolf's pelt up from his chest into his face and hair, and the creature was given no hairline. His eyebrows were removed, and actor Dave Legeno wore very dark contact lenses that reflected light back in the same way as a wolf's eyes do.

In order to achieve the subtlety of Greyback's wolfish hair, the creature makeup consisted of seven silicone prosthetics that were painted and then painstakingly punched with individual goat hairs. Punching the hairs in meant that no glue needed to be used, which gave a better freedom of movement. These pieces were placed on the actor's face, chest, and ears. The number of pieces allowed the makeup artists easier manipulation than if they had used two or three large ones, and ensured a more accurate application. The pieces were destroyed by the removing agent when they were taken off at the end of the day, so new pieces were needed for each day of filming. A multitude of each prosthetic piece was created and stored much earlier in the shooting schedule so new prosthetics could be prepared and applied each day.

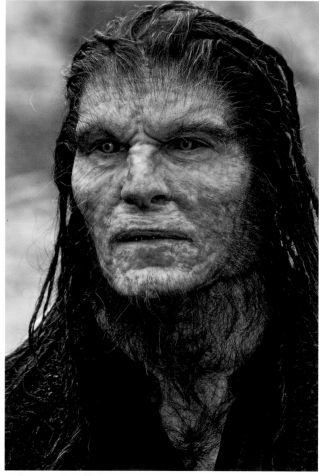

Fig 1.

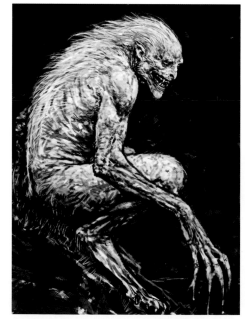

Fig 2.

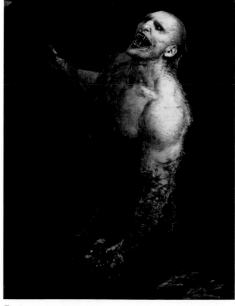

Fig 3.

Fig 1. Dave Legano as the increasingly wolfish Fenrir Greyback in *Harry Potter and the Deathly Hallows – Part 2*; Fig 2. Fenrir Greyback by Rob Bliss for *Harry Potter and the Half-Blood Prince*; Fig 3. Greyback by Rob Bliss for *Deathly Hallows – Part 2*; Fig 4. A Rob Bliss portrait of Greyback for *Half-Blood Prince*; Fig 5. Dave Legano (Fenrir Greyback) strikes a snarling pose for *Half-Blood Prince*.

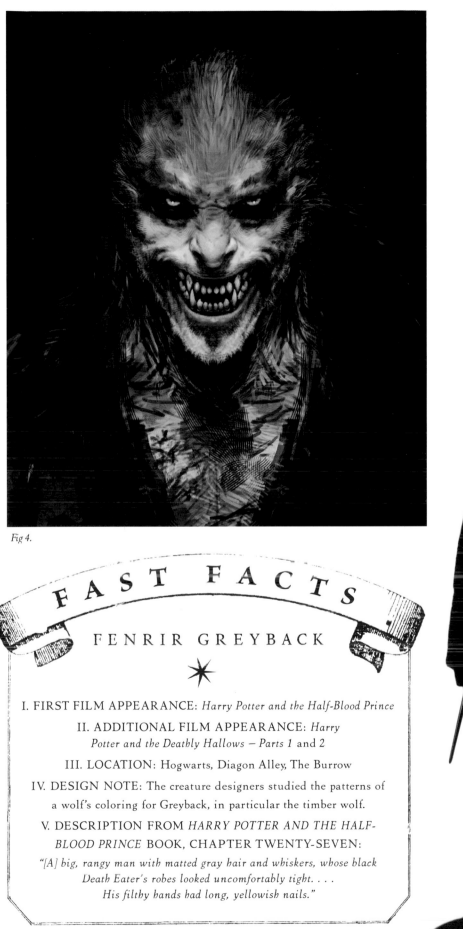

Fig 4.

Fig 5.

FAST FACTS

FENRIR GREYBACK

✦

I. FIRST FILM APPEARANCE: *Harry Potter and the Half-Blood Prince*

II. ADDITIONAL FILM APPEARANCE: *Harry Potter and the Deathly Hallows — Parts 1 and 2*

III. LOCATION: Hogwarts, Diagon Alley, The Burrow

IV. DESIGN NOTE: The creature designers studied the patterns of a wolf's coloring for Greyback, in particular the timber wolf.

V. DESCRIPTION FROM *HARRY POTTER AND THE HALF-BLOOD PRINCE* BOOK, CHAPTER TWENTY-SEVEN:

"*[A] big, rangy man with matted gray hair and whiskers, whose black Death Eater's robes looked uncomfortably tight. . . . His filthy hands had long, yellowish nails.*"

INSIGHT
EDITIONS

PO Box 3088
San Rafael, CA 94912
www.insighteditions.com

 Find us on Facebook: www.facebook.com/InsightEditions
 Follow us on Twitter: @insighteditions

Library of Congress Cataloging-in-Publication Data available.

ISBN: 978-1-68383-829-6

Publisher: Raoul Goff
President: Kate Jerome
Associate Publisher: Vanessa Lopez
Creative Director: Chrissy Kwasnik
Designer: Megan Sinead Harris
Editor: Greg Solano
Managing Editor: Lauren LePera
Senior Production Editor: Rachel Anderson
Production Director/Subsidiary Rights: Lina s Palma
Senior Production Manager: Greg Steffen

Written by Jody Revenson

ROOTS of PEACE REPLANTED PAPER

Insight Editions, in association with Roots of Peace, will plant two trees for each tree used in the manufacturing of this book. Roots of Peace is an internationally renowned humanitarian organization dedicated to eradicating land mines worldwide and converting war-torn lands into productive farms and wildlife habitats. Roots of Peace will plant two million fruit and nut trees in Afghanistan and provide farmers there with the skills and support necessary for sustainable land use.

Manufactured in China by Insight Editions

10 9 8 7 6 5 4 3 2 1